IMAGES
of America

PALM DESERT

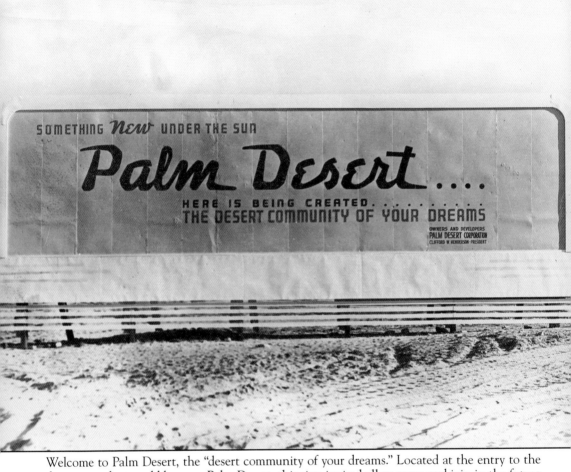

Welcome to Palm Desert, the "desert community of your dreams." Located at the entry to the desert area that would become Palm Desert, this sign invited all to come and join in the future of this community.

ON THE COVER: Early development in Palm Desert centered around the Shadow Mountain Club, which provided members with numerous social and recreational opportunities. The famous figure-eight pool was the center of attention during the four-day grand opening in 1948 and featured a surfboard ballet, aquacade, diving exhibition, and comedy diving routines. (Historical Society of Palm Desert.)

IMAGES
of America

PALM DESERT

Historical Society of Palm Desert

Hal Rover, Kim Housken, and Brett Romer

ARCADIA
PUBLISHING

Published by Arcadia Publishing
Charleston SC, Chicago IL, Portsmouth NH, San Francisco CA

Printed in the United States of America

Library of Congress Catalog Card Number: 2008928804

For all general information contact Arcadia Publishing at:
Telephone 843-853-2070
Fax 843-853-0044
E-mail sales@arcadiapublishing.com
For customer service and orders:
Toll-Free 1-888-313-2665

Visit us on the Internet at www.arcadiapublishing.com

Grace "Tripalong" Boyd, wife of William "Hopalong Cassidy" Boyd, showed off her riding abilities at the dedication of the Hopalong Cassidy Trail. She was nicknamed "Tripalong" because of her short stature relative to her husband.

CONTENTS

Acknowledgments 6

Introduction 7

1. Early Ranchers 9

2. Palm Village and the War Years 19

3. It Took a Family 33

4. The Shaping of Shadow Mountain Club 41

5. Canyons, Coves, and High Places 61

6. Building a Community 79

7. Famous Folk and Colorful Characters 101

8. Today in Palm Desert 119

ACKNOWLEDGMENTS

Thanks to the Historical Society of Palm Desert (HSPD), without which this book would never have happened. Former mayor Ed Mullins conceived of a historical commission of early pioneers to collect and store historic material. The five appointed trustees were Patricia Anderson, Ann Carpenter, Jeannette Constantino, Hal Kapp, and Evelyn Young.

The City of Palm Desert has been involved in many ways, particularly by maintaining the first fire station as the current home of the Historical Society of Palm Desert. City leaders, both past and present, have ensured our successful progress. We commend city staff Sheila Gilligan, Donna Gomez, Pat Scully, and Frankie Riddle for their ongoing support.

At HSPD, archivist Ginny Folkers has singularly shouldered the effort to preserve the history of Palm Desert. The board of directors allowed access to the archives and provided additional materials and support. Administrator Ann Tuttle was always willing to help. HSPD members Dan Callahan, Jan Holmlund, Bonnie Bowie, Gloria Petitto, Don and Duchess Emerson, Walt and Kay Eichenhofer, Yvonne Riddell, Phil Franklin, Robert Ricciardi, Jean Hanousek, and countless others have assisted us. We thank them all.

We must also recognize our editor, Debbie Seracini, and commend Jeanne LeDuc for her thorough review, without which we would not have completed this task.

Much appreciation goes out to all of the individuals who have taken the time to share their lives with us by giving their oral histories. Local journalist Ann Japenga motivated us and fostered a much deeper importance to the mission. The Shadow Mountain Golf and Resort provided history back to 1948. For all the others not named who assisted with this project, please accept our gratitude. Additionally, we thank our spouses for their patience and support.

This book is the result of the efforts of three amateur historians who wanted to share the story of Palm Desert. Any errors or omissions are strictly unintentional.

All photographs used in this book are from the HSPD archives of the Historical Society of Palm Desert, unless otherwise noted.

INTRODUCTION

While predominately developed in the second half of the 20th century, the area known as Palm Desert has seen human occupation for thousands of years. Archaeologists say the most recent identifiable native culture to evolve in the Coachella Valley region is that of the Cahuilla Indians. Historically, the Cahuilla were hunters and gatherers who occupied three geographic regions: desert, mountain, and passes. The Kauisik lineage of the Cahuilla had gathering rights from Palm Springs east to Palm Desert and south into the mountains near Pinyon.

The cove area that would become Palm Desert was first called "Sand Hole" by government surveyors in the 1850s. With later warnings from the U.S. Army Corps of Engineers to refrain from building on this 1,000-foot alluvial fan, future inhabitance was doubtful. Many coves like this one, nestled against the Santa Rosa Mountains, appeared ominous for homesteaders, mainly because of dangerous seasonal thunderstorms and flooding. However, the flatlands to the north eventually enticed adventurous homesteaders eager to stake a claim in this once forsaken desert.

Prior to these early homesteaders, confidence grew throughout the greater Coachella Valley area as the Southern Pacific Railroad was extended from San Bernardino east to Indio, in 1876, and on to Yuma, Arizona, in 1877. With the steam engines' requirement for water, the railroad drilled wells to meet the demands of their trains. With the realization that water was plentiful, folks traveled great distances to stake claims in this sun-baked fertile valley. Eastern valley towns of Indio, Coachella, Thermal, and Mecca were developing, and by the 1880s, Agua Caliente (Palm Springs) was growing.

The area around Sand Hole was first homesteaded in approximately 1910, and successful water wells were drilled. In a roughly 36-square-mile area bounded by Rio del Sol (now Bob Hope Drive) on the west, Washington Street on the east, Country Club Drive on the north, and the steep Santa Rosa Mountain coves to the south, there were reportedly 18 wells drilled by 1919. Most of the early homesteads were located north of present-day Highway 111. Around 1930, developer William Johnson began acquiring some of this land and named the area Palm Village. Homesteaders also staked claims in neighboring coves, which would eventually develop into cities of Cathedral City, Rancho Mirage, Indian Wells, and La Quinta.

During World War II, the U.S. Army commandeered land south of Palm Village to house a camp for the repairing of all army mobile equipment, such as tanks, jeeps, and trucks. This area was used as a support base for the sprawling 18,000-square-mile Desert Training Center located at Camp Young near Chiricao Summit, 40 miles east of Palm Desert. The Desert Training Center site was selected by Gen. George S. Patton and covered areas of California, Nevada, and Arizona. Troops were trained for eventual North African battle against Germany's "Desert Fox," Field Marshall Erwin Rommel.

At the conclusion of World War II, interest grew in this desert area 120 miles east of Los Angeles. The four brothers of the Henderson family were attracted to the possibility of building a master-planned community from inception to completion and set their sights on the area recently

vacated by the army. This dream became a reality as Cliff, Randall, Carl, and Phil began to play roles in realizing a resort, as well as a large printing facility and art gallery. The four brothers were experiencing career successes in differing locations and their reuniting in Palm Desert was the spark that created our community. History proved the Hendersons and their supporters correct in pushing for a "Dream to Reality," the Palm Desert we know today.

Since the community's inception in the 1940s, growth has been steady. With the arrival of the *Desert Magazine* building and development of the Shadow Mountain Club, the population began booming. This necessitated the building of the first school, post office, church, fire station, drugstore, gas stations, and many commercial businesses to support the growing community. College of the Desert soon followed, and eventually Eisenhower Hospital was opened in adjacent Rancho Mirage.

National interest in desert lifestyle grew through the 1960s and 1970s as outdoor recreation and leisure time activities gained momentum. This led to the development of exclusive country clubs and gated communities where members could play a round of golf, swim, or take in a tennis match, and in the evening enjoy fine dining without leaving their comfortable surroundings. During this time, the concept of condominiums gained acceptance. These master-planned communities provided owners with added amenities and a built-in social life. Turnkey units allowed new residents to move easily into the desert lifestyle and fueled the economic growth and development of the area.

Since the incorporation of Palm Desert in 1973, cultural and educational opportunities continue to expand and provide a high quality of life for its citizens. Tourism drives a robust economy as major hotels, cultural centers, and centers for learning are realized. Today Palm Desert is known for its surrounding rugged, mountainous landscape, beautiful hourly changing earth-toned hues, and winter snowcapped peaks. While winter nights can be brisk and the summer days can be quite hot, the daytime temperatures average in the mid-70s, allowing outdoor activities for many year-round.

Palm Desert's El Paseo is known as the "Rodeo Drive of the desert." One can enjoy a leisurely stroll down El Paseo, taking in the many works of art on display as part of the city's Art in Public Places program, visiting numerous galleries, shopping in some of the finest establishments, or dining in one of the many fabulous restaurants. And that is just one street of this outstanding community. After leaving El Paseo, one can enjoy golfing, tennis, and swimming or relax at the many city parks. It should be noted that the city parks are youth friendly, providing soccer fields, baseball diamonds, skate parks, swings, and large grassy areas. Summer evenings at the city parks are pleasant and entertaining with concerts and activities provided by the city. Palm Desert is people friendly.

Palm Desert, as envisioned by the Hendersons, has indeed become the city of their dreams.

One

EARLY

RANCHERS

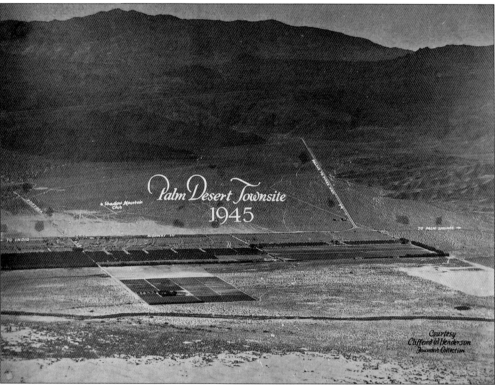

Charles McDonald received a land patent in 1903 and is the earliest known rancher in what became Palm Village. McDonald owned a lumberyard in Coachella. He installed a well, pumping plant, and reservoir on his 480-acre ranch in order to cultivate the land. After five attempts at growing hops, he sold his ranch in 1929 to King C. Gillette (of razor fame) and partner Thomas Rosenberger. Following the lead of other ranchers in the Coachella Valley, they converted the ranch to grapefruit groves. In the process, they dug five additional wells and built six homes. This aerial view was taken from what is now north Palm Desert looking south across the Whitewater Channel. The ranch in the foreground would have been similar to the Gillette Ranch. However, this land was used for grapes and alfalfa and was owned by ventriloquist Edgar Bergen from 1942 to 1948. Today all that remains of the property is a 1937 home. Most of the early ranches were located north of Highway 111.

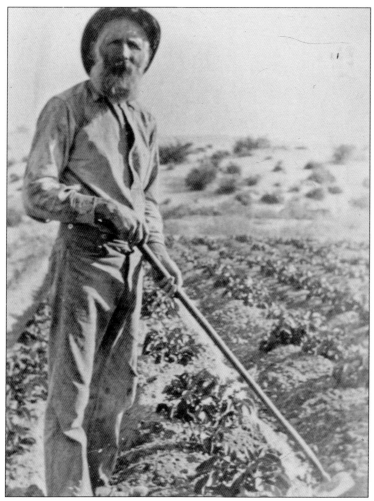

William P. Blair arrived in the Coachella Valley in 1909 and was one of the earliest settlers. Seen here hoeing melons, Blaire was able to overcome the natural barriers to ranching in this barren desert: intense heat, high winds, blowing sand, and, most importantly, lack of surface water. Note the large sand dunes just behind Blaire's home (seen below). Blair's homestead was located in the area west of the Tennis Gardens in what is now Indian Wells. A flood in 1916 wiped out much of Blair's ranch. The Whitewater Channel was later built to control desert and mountain runoff in the area.

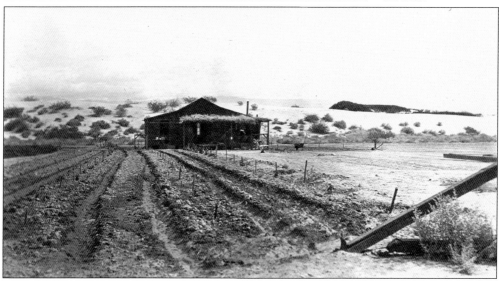

Robert W. Blair, William's son, was a blacksmith and drilled water wells. Records show that he drilled many of the early wells in the area, including six prior to 1919. Below is a later view of the rebuilt Blair homestead, looking southwest. Eisenhower Mountain, named after the 34th president, is in the background. Visible is a windmill, which all early ranchers needed to pump water from their wells. Eventually windmills were replaced with electric pumps. In the 1980s, windmills were reintroduced to the desert as an alternative energy source. These wind farms can be seen along Interstate 10.

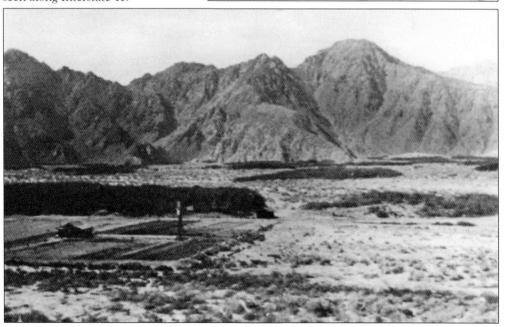

In 1913, Caleb Cook (left) staked a 160-acre claim in the area and turned it into a productive Deglet Noor date ranch. While clearing land, ranchers encountered rattlesnakes living in the mesquite thickets. A common ratio used by ranchers was one rattler per acre.

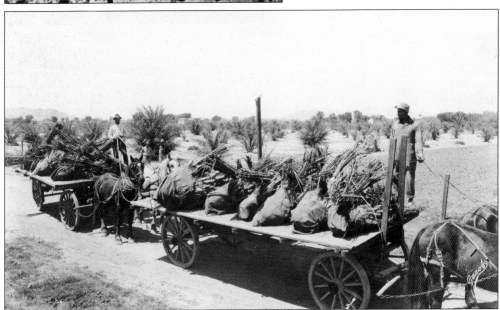

Cook transported date palm offshoots from his Yuma, Arizona, ranch to the Coachella Valley for planting. The valley climate was ideal for date production and continues as one the few areas in the world today where this delicacy is cultivated. Ranchers used offshoots to guarantee the required ratio of female and male palms. Cook Street is named after this early rancher.

A date grove can be compared to a harem, since there are usually 48 females to one male tree per acre. Female blossoms are odorless and therefore not likely to be pollinated by insects. To ensure a successful crop, dates are pollinated by hand. Workers scaled a ladder attached to the tree trunk to access the flowers for pollination. As the fruit neared maturation, workers wrapped the date clusters with strong paper to protect the fragile fruit (below). To protect citrus trees from frost, they were sometimes interplanted in date groves for shelter. However, because of different watering needs of the two trees, the practice was abandoned.

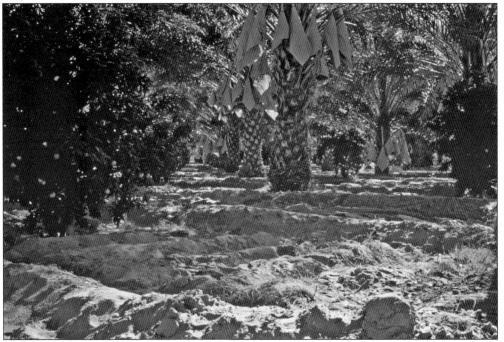

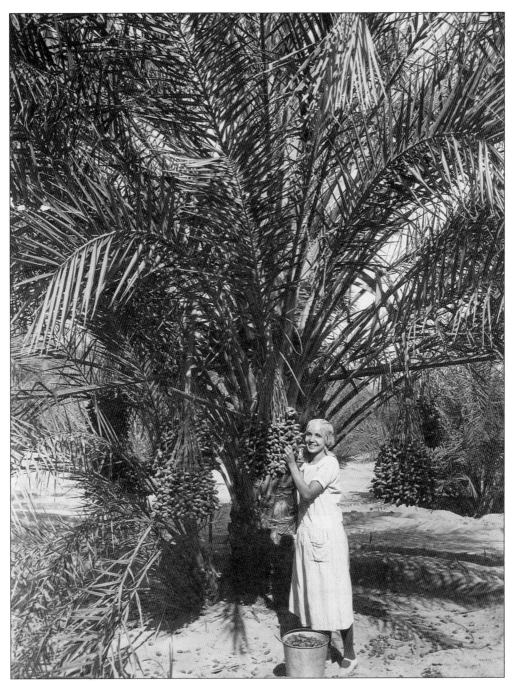

Seen harvesting dates on the Cook date ranch in about 1926 is a smiling Luisita Montoya. During harvest, ripe dates were carefully hand selected from those not yet mature. In some cases, a tree needed to be visited up to eight times before all of its fruit was gathered. The tree shown here is a younger palm. Mature trees can grow to 100 feet. After being cleaned and hand graded, the dates were refrigerated to maintain proper moisture content before being packed and shipped. Date quality was paramount to the Coachella Valley industry. Only the very highest grade of dates qualified to be sold as "Whole Natural Dates."

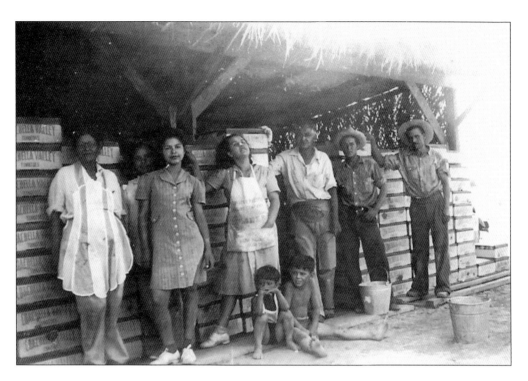

Date cultivation was labor intensive, so ranchers required many laborers. Members of the Montoya family hired out to several of the area ranches. Margy (right), in the center, is seen in front of a packing shed around 1946, with her young sons Richard (right) and Ben (left). Ben and his brother Art (not shown) fondly recall stopping in at Ripples Date Garden (below) on Highway 111 as young boys to visit "Aunt Juanita." They were treated to their favorite milkshake—a date shake, of course!

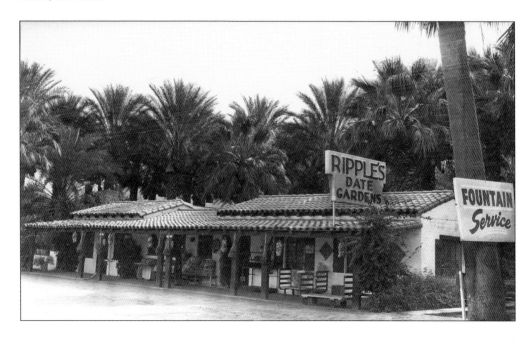

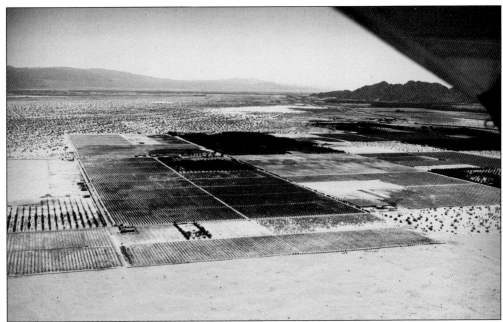

Paul Kersten, a German immigrant, grew grapes and dates on his 240-acre ranch located on the west side of Rio Del Sol (renamed Bob Hope Drive). The acreage directly east of Kersten's property was owned by Hank Gogerty, a prominent Los Angeles architect. Gogerty developed Desert Air Hotel/Palm Desert Airpark so he could fly out from Los Angeles to easily access his ranch property. The visible east-west trail in the photograph became Country Club Drive. Kersten's property is now the site of The Springs Country Club. Eisenhower Hospital is located on the Gogerty land. Kersten also owned a fruit-packing operation (below). Fruits were transported to distant markets by train from the Indio or Palm Springs stations.

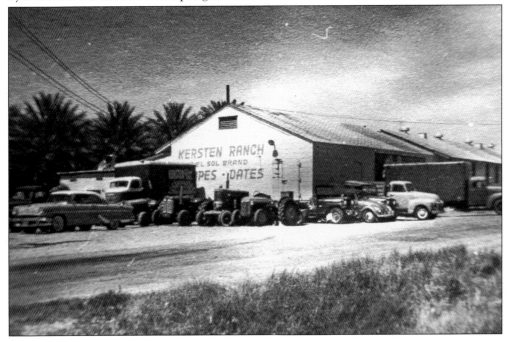

The holidays were a busy time for mail-order date sales in the Coachella Valley. Many of the ranches also had roadside shops to sell their products to both locals and travelers passing through the area via Highway 111.

Numerous ranches are pictured looking east between Deep Canyon Road and the mountain coves of present-day Indian Wells. The darker fields are date palm groves. Also note the Whitewater Channel that divides the agricultural area to the south from undisturbed desert.

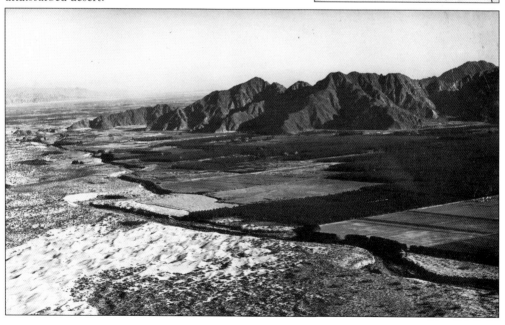

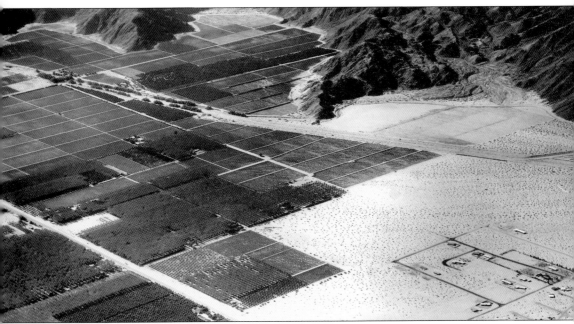

Grapes, dates, and citrus were the predominant crops grown in the Palm Desert area in the early ranching period. The unoccupied cove in the top right now encompasses The Vintage Club, built in 1979. Page Ranch, in the center and left coves, became Eldorado Country Club in 1957. Milton Page, owner of the Pioneer Club in Las Vegas, won the deed to this 792-acre ranch in a high-stakes poker match. Over time, ranch properties gave way to country clubs and other development, particularly in the protected mountain coves.

Two

PALM VILLAGE AND THE WAR YEARS

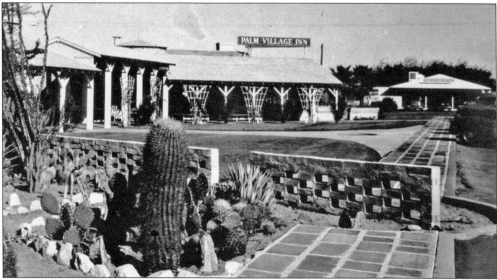

In the 1930s, William Johnson of American Pipe and Construction Company purchased 320 acres of the Gillette Ranch. He hired Charles Gibbs Adams, the noted landscape architect of the Hearst Castle Gardens, to design a residential project. Nearby Palm Springs was a rapidly developing resort area, and he sought to replicate this success to the east. Innovations included curving streets so each lot had a mountain view. The ranch reservoir was converted to a swimming pool. Although the backbone infrastructure was built, the project was plagued by poor timing during the Great Depression and failed. In 1940, the Mollin Investment Company bought the project and named it Palm Village. The company targeted buyers from Los Angeles and had better success. Manager Guy Wilson had a novel solution to the encroaching "devil grass" (Bermuda grass) from the adjacent groves. He released about 100 pigs into the area. When the winds shifted, the distinctive smell of the "mowers" was noted by many of the villagers. By the time the U.S. Army arrived in 1943, several homes were developed and the first restaurant, Palm Village Inn, had opened.

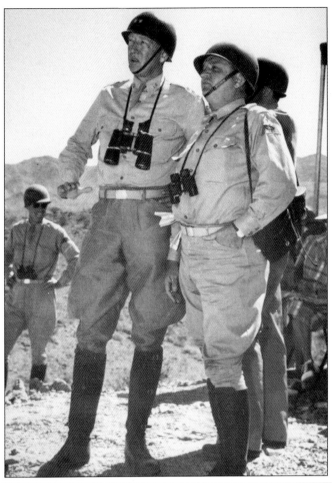

Gen. George Patton (left) and Gen. Walton Walker observed tactical maneuvers at the Desert Training Center (DTC) in May 1942. Patton established the DTC 40 miles east of Palm Village as a training ground for troops deploying to the North African desert. Roughly twice the size of Maryland, and extending into Arizona and Nevada, it was the largest military training area in the world. In the spring of 1943, the army established a camp located across Highway 111 from Palm Village. The camp extended south into the rocky mountain cove of Deep Canyon. Initially the Palm Village camp was used to replicate troop encampments in open desert warfare. Troops practiced camouflage and concealment of military equipment and operations. Note the two buried tents to the right of the truck. (Below photograph courtesy of Julian Gocek.)

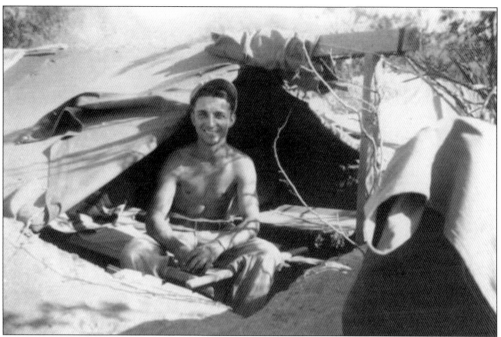

Julian Gocek, a Technician 5 with the U.S. Army, arrived in Palm Village on March 8, 1943, after 10 months at the DTC. Gocek is seen relaxing in his sunken tent, a long way from his hometown of Syracuse, New York. Soldiers dug and lived in foxholes, housing two to six men, for several months during the duration of their exercise. Below is Gocek (left) with two members of his unit. Palm Village was sparsely populated, so the camp commander sent soldiers to Los Angeles for R and R. In June 1943, Gocek's unit was designated to the 897th Ordnance Heavy Automotive Maintenance Company. The company left Palm Village in July 1943. They landed on Omaha Beach nine days after D-Day, June 6, 1944. They were the first maintenance unit to land at Normandy. (Photographs courtesy of Julian Gocek.)

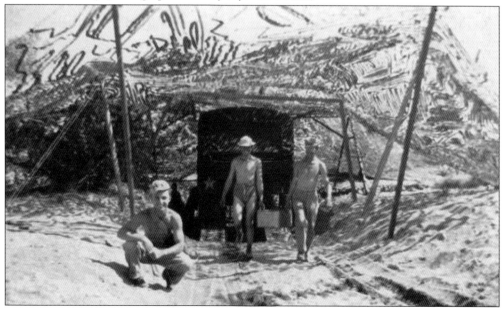

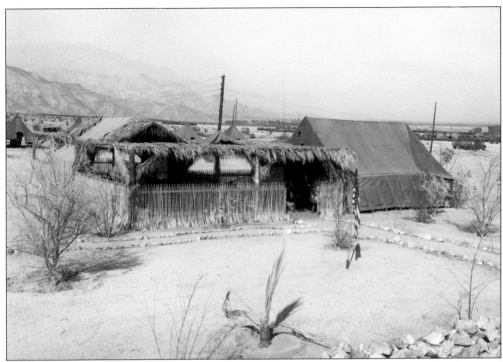

The army began using the Palm Village camp in the summer of 1943 as a vehicle pool and a repair/maintenance facility. Tents were erected and buildings constructed of post and beams, with palm fronds used for roofs and walls. The structure above served as the office for the commanding officer of the 243rd Ordnance Battalion and Vehicle Pool in October 1943. It was located on open desert near present-day Washington Charter School. Due to the harsh desert conditions and lack of roads, vehicles and equipment used for maneuvers at DTC and area camps required frequent repairs and maintenance. Below is a repair area that serviced trucks and jeeps. While nearly all of the camp was set up on the open desert, large concrete pads were used in the service bays. These pads were one of the few reminders of the army's deployment in this area.

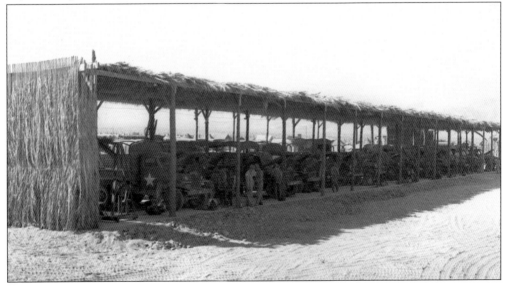

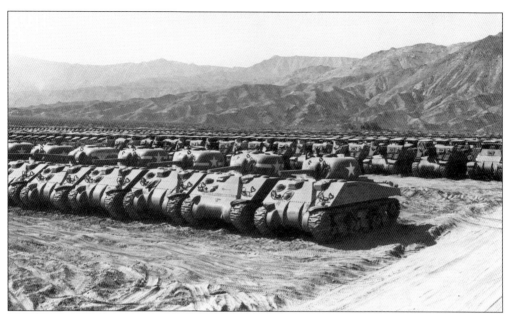

Mile-long military convoys poured into the Palm Village camp. Villagers reported hearing the sounds of hammers and drills at all hours. Nearly 6,000 tanks and field artillery passed through the camp either returning to the Desert Training Center or shipped by train out of Indio for deployment overseas. Tanks were given test runs in the cove south of the camp up into rugged terrain of Deep Canyon. Since the camp was not fenced, army guards paced up and down Highway 111. Visible in the distance, behind the army communications truck (below), is Mount San Jacinto, which rises over 10,000 feet above Palm Springs.

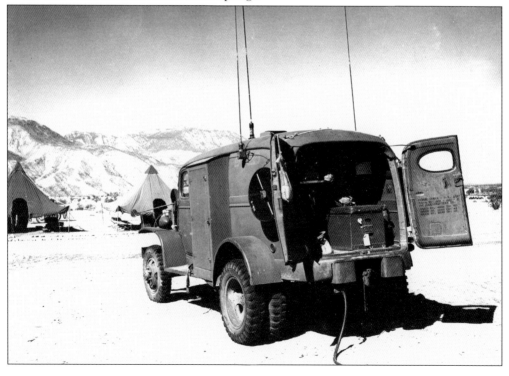

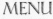

MENU

ROAST TURKEY
SHRIMP COCKTAIL WITH TOMATO SAUCE
SAGE AND ONION DRESSING
CRANBERRY SAUCE
CANDIED SWEET POTATOES
SNOW FLAKE POTATOES
BUTTERED PEAS
RIPE OLIVES
SWEET MIXED PICKLES
PUMPKIN PIE
FRUIT CAKE
SOFT COOKIES
MIXED NUTS
HARD CANDY
FRUIT PUNCH
CIGARS
CIGARETTES

★

COOKS

MESS SGT., S/SGT. STACK	T/5 STEWART
T/4 GROCE	PFC. DOUGLAS
T/4 HUGHEN	PVT. GRITMAN
T/5 BLACKMAN	PVT. RICHARDSON

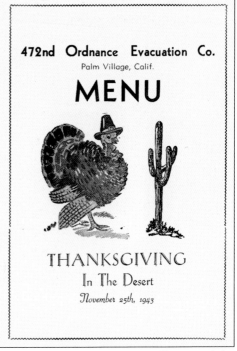

472nd Ordnance Evacuation Co.
Palm Village, Calif.

MENU

THANKSGIVING
In The Desert
November 25th, 1943

Soldiers looked forward to mealtimes as a break from their daily regimen, especially around the holidays. The 1943 camp menu above shows that soldiers dined on many of the same dishes we enjoy today on Thanksgiving. Note the invitation for a smoke after the meal. By May 1944, the Palm Village camp had been closed and dismantled. The 1947 aerial photograph below looks east and shows Palm Village to the left of Highway 111 and the early streets of Palm Desert, including El Paseo, paralleling the highway on the right. The lighter area in the center of the photograph marks the area occupied by the army.

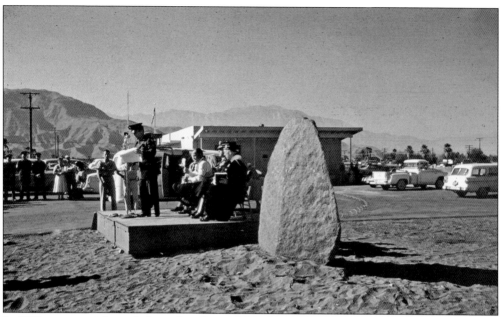

In 1958, a memorial was dedicated to General Patton and his troops. Military history buffs later pointed out that Patton and the 1st Armored Corps never visited Palm Village. Yet it still remains as recognition of the many troops that trained in the area during World War II. The memorial was initially placed on El Paseo. Later it was relocated south to the first library building on Portola, now the home of the community center, where it stands today.

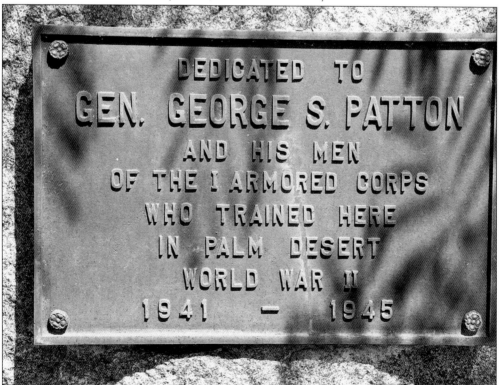

DEDICATED TO
GEN. GEORGE S. PATTON
AND HIS MEN
OF THE I ARMORED CORPS
WHO TRAINED HERE
IN PALM DESERT
WORLD WAR II
1941 — 1945

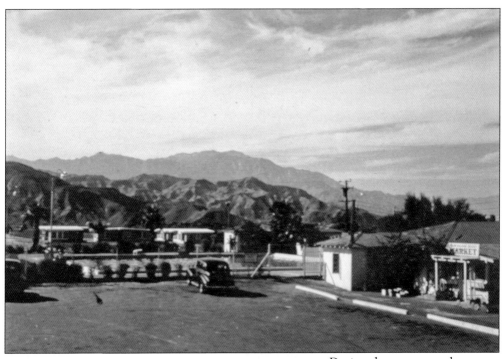

HEALTHFUL, QUIET
DESERT LIFE
Enjoy *at Palm Village*
NEAR PALM SPRINGS, CALIF.

LIVE A LIFE OF CONSTANT ENJOYMENT AT PALM VILLAGE IN THE SUN DRENCHED, UNSPOILED DESERT.

SWIM in a glamorous pool.

PLAY tennis, badminton, golf.

HORSEBACK rides up the trails of the palm studded canyons.

HIKES to the Cathedral-like date gardens.

TRIPS to the snow capped mountains in 30 minutes.

PICNIC on the shores of the Salton Sea 40 miles away.

ENJOY night club life at Palm Springs.

SHOP at Palm Village shops.

BUSINESS OPPORTUNITIES AWAIT YOU HERE

WRITE for descriptive circular picturing $1,000,000 improvements.

LOTS START AT $795.

PALM VILLAGE *Desert Homes*
P. O. BOX DD, PALM SPRINGS, CALIFORNIA

During the war years, the area was still a remote desert outpost. The swimming pool William Johnson converted from the ranch reservoir in Palm Village was a welcome place to escape the desert heat. Each villager was given a gate key to access the pool, which they shared with soldiers during army deployment in the area. Air-conditioning was not available in cars yet, so residents and visitors used wet towels to wrap their heads and neck as they drove through the hot desert. These "desert minks" were not quite fashionable but served their function well during summers in particular, when temperatures reached upward of 120 degrees. The pool site was located next to Palm Village Inn, west of Portola Avenue on Highway 111.

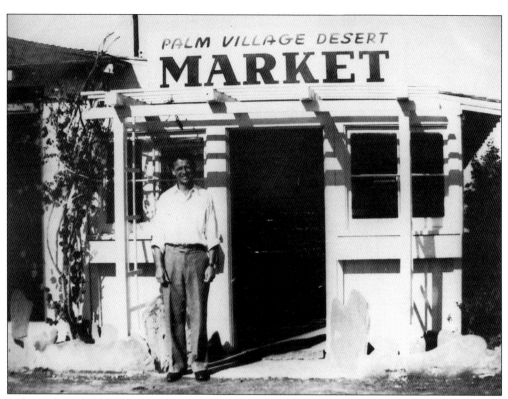

Bob Keedy arrived in 1945 to manage the Palm Village Desert Market, first located in the pump building next to the community swimming pool. Mollin Investment Company divided the building and provided a freezer and evaporative cooler for this first grocery store. No longer did the villagers have to drive to Indio for provisions. In the fall of 1946, the market relocated to a new building. Built by Mollin Investment to better serve residents, it was considered a full-service grocery market—residents claimed they always had butter and bacon when other valley stores were out. The grand opening was the talk of the village, as there were only a handful of businesses in the area at the time. The building is still standing at 74104 Highway 111.

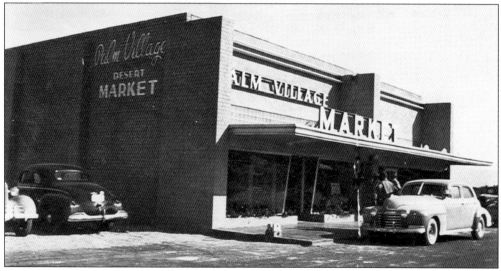

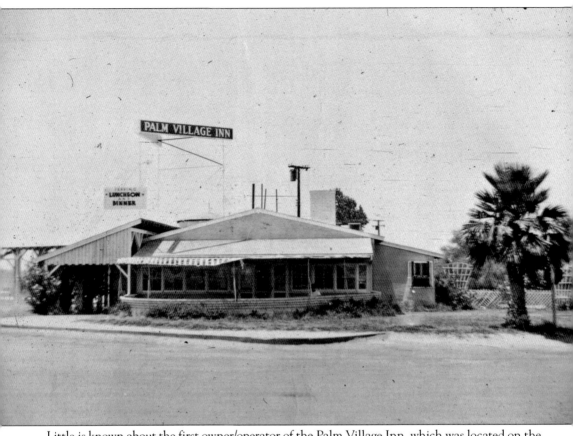

Little is known about the first owner/operator of the Palm Village Inn, which was located on the northwest corner of Highway 111 and Portola Avenue. During the army encampment at Palm Village, it often had a line of off-duty soldiers eager for food and cold beverages. Grace and Rocky Hume took over the inn in 1945, later purchasing the property. Specializing in chicken, steaks, chops, and prime rib, Grace claimed the food had to be good to convince people to drive all the way from Palm Springs or Indio. Pilots even flew in from Thermal to dine, landing on the nearby hard-packed desert previously used by the army. Staffing was difficult, so Grace would pick up the dishwasher in Indio, returning him home each night. Housing was scarce at the time, so the Humes slept in a back room at the inn and the cook in a trailer on the property. During the building of Shadow Mountain Club, the inn stayed busy feeding the many workers. In 1947, the Humes sold the Palm Village Inn to Doc Gurley.

Angelo Potencia purchased the Palm Village Inn from Doc Gurley in about 1948. While retaining the name Palm Village Inn, he also added his own name. Soon the place was known as Angelo's. To promote his restaurant and bar, Angelo decided to have a tall palm tree planted at the site. Millard Wright, a Coachella house and tree mover, delivered the tree but refused to plant it until Angelo paid up. After the tree sat on a dolly for five days, locals wagered as to when it would be planted. Another five days passed, and the pool reached $8 by the time Angelo made good on his bill. Using a crane, Wright lifted and planted the tree in front of the restaurant. This palm can still be seen growing at the northwest corner of Highway 111 and Portola Avenue.

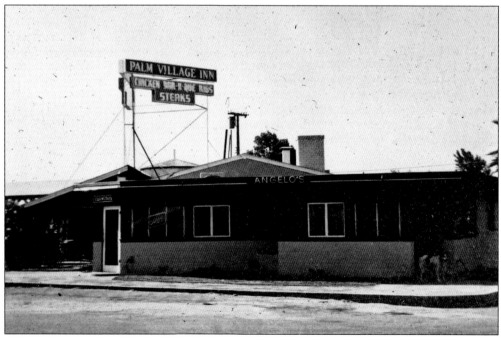

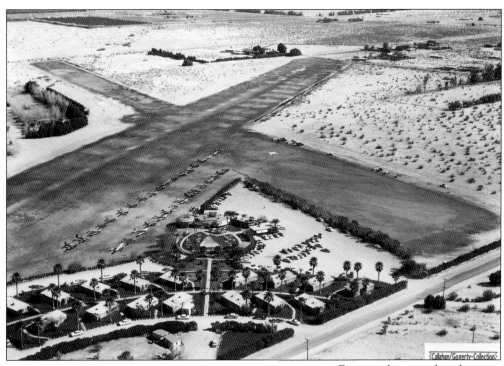

Callahan/Gogerty Collection

Few people remember that Palm Desert once had an airport. Palm Desert Air Park, site of the Desert Air Hotel, was located north of the intersection of Highway 111 and Rio Del Sol (now Bob Hope Drive) in present-day Ranch Mirage. Hank Gogerty developed the property as an airpark in 1945 so he could easily access his ranch property located to the north. Gogerty purchased government barracks in 1947 and converted them into 16 rental cottages. By 1950, as the 3,400-foot grass airstrip grew in popularity, a pool, restaurant, and bar were added. A second cross runway was added in the 1950s to the private air park. The runway was used on occasion as a polo field. While in play, a large white X was placed on the runway to warn pilots away from that strip.

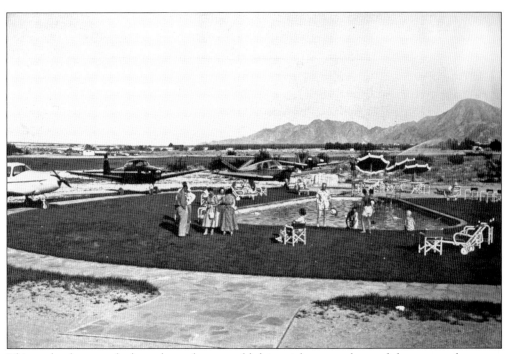

This early photograph shows how planes could drive right up to the pool; however, subsequent additions stopped this practice. Billed as "The West's Finest Desert Resort," the airpark attracted celebrities and pilots alike. It was also used for filming scenes in the 1963 film *It's a Mad, Mad, Mad, Mad World*.

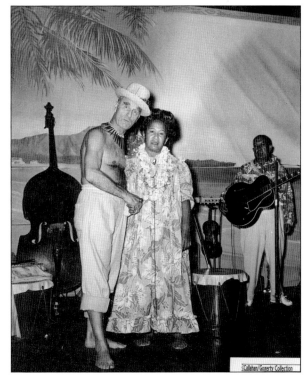

Seen here with owner Hank Gogerty in the 1950s, Hilo Hattie, a noted Hawaiian entertainer, sang at the end-of-season luau at Desert Air. Luaus were popular during the 1950s, and the event attracted over 1,200 people. A pit-roasted pig was always featured, and guests enjoyed dressing in island attire.

31

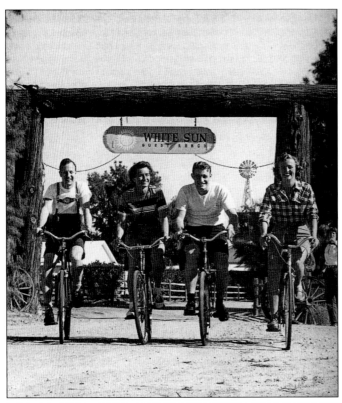

Immediately adjacent to Desert Air Park was the 50-acre White Sun Guest Ranch. Seen departing the ranch beneath the enormous redwood log entry are a group of international students going on a bike ride. In the 1940s, owners Jack and Helen Dengler developed the former ranch property into the first family-oriented, all-inclusive guest ranch. Ranch activities included chuck wagon breakfasts, trail rides, tennis, golf, swimming, nightly entertainment, and campfires. During this era, guest ranches were popular with families seeking outdoor adventure—it is reported that 75 percent of the guests were repeat visitors.

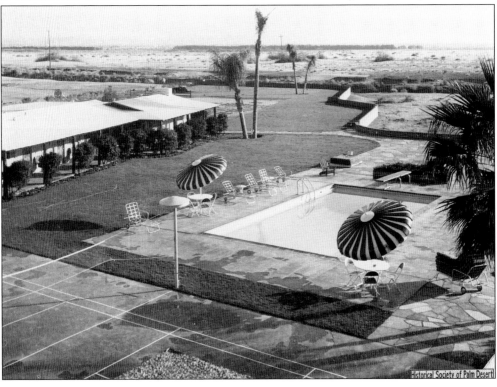

Three

It Took
a Family

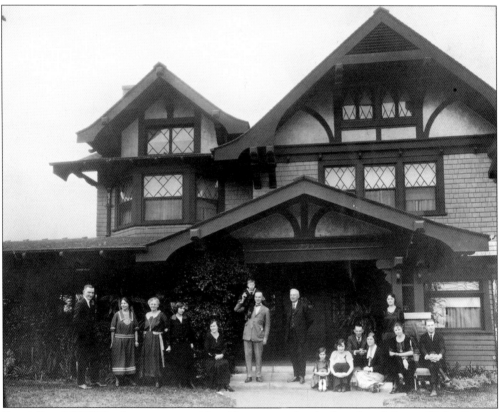

Randall and Cliff Henderson are considered by many to be the founding fathers of Palm Desert. They were born in Clarinda, Iowa, along with brothers Carl and Phil and sister Dorris between 1888 and 1903. Their father, Nelson, was the town druggist. Their mother, Mary, instilled in her children Midwestern values, work ethic, and self-sufficiency. Each of the children moved west to seek fortune. Randall made a name in the publishing industry, while his brother Cliff was a high-flying event promoter and entrepreneur. Phil and Carl worked in a variety of ventures with their brothers. They all worked to create a city out of a little-known desert in Southern California. From left to right is the extended family: Carl, Vera, Mary Catherine, Hope, Sadie, Randy, Randall, Nelson, Evonne, Dorris, Phil, Faith, Hattie, Helen, and Cliff Henderson.

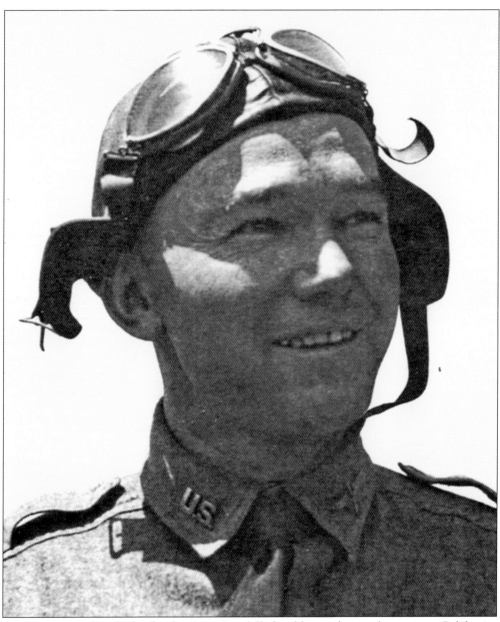

After graduating from high school in Iowa, Randall, the eldest, rode a cattle car out to California. He enrolled at the University of Southern California (USC), making his mark as student body president and captain of the basketball team. He worked a variety of part-time jobs, notably as sports reporter for the *Los Angeles Times*. After graduating in 1911, and on the advice of sportswriter Henry Carr, he took an apprenticeship with the *Parker Post* in Arizona. Eventually he made his way to Blythe, then Calexico, to publish other newspapers. It was here that J. Wilson McKenney became the front office manager of the *Calexico Chronicle* and later partnered with Henderson in the *Calipatria Herald*. In 1937, Randall and J. Wilson partnered to start *Desert Magazine*, a national publication dedicated to the Southwest deserts. Ten years later, Henderson, seeking refuge from the restrictions of city life in El Centro, relocated the magazine to Palm Desert so he could enjoy the undeveloped desert expanse.

During a brief stint in the Army Air Corps during World War I, Randall earned his wings, and flying became a way for him to traverse and explore the vast deserts of California. He was the first pilot to land at Henderson Field in Las Vegas in 1920. He offset fuel costs by selling rides in a Curtiss Jenny with partner Ray Seeley.

Henderson's main occupation was still reporting and publishing, and he covered many of the National Air Races. He is seen below, fifth from the left, at the 1936 National Air Races held in Los Angeles.

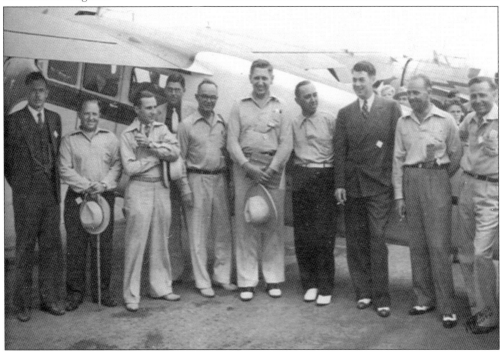

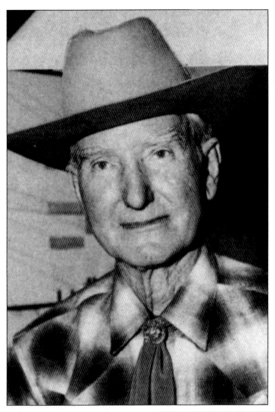

Carl Henderson worked his way through USC as an athletic trainer. After graduation, he operated grain, alfalfa, and dairy ranches in the San Joaquin Valley. In 1920, he moved to Santa Monica and went into car sales, later acquiring a local Packard agency. His success led to Santa Monica becoming known as "The Packard City." Carl later branched out into real estate and development. His streamline moderne Vanity Fair Apartments survive today as a Santa Monica Historic Landmark. He was involved in civic life and was captain of the Santa Monica Mounted Police. Seen at left, Carl brought his real estate experience to the desert in the 1940s and helped shape Palm Desert.

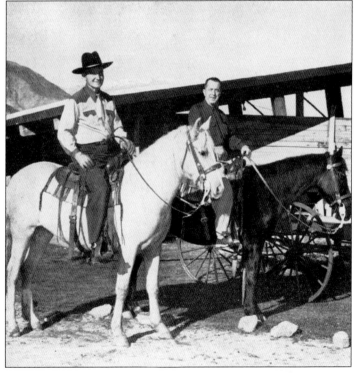

Phil Henderson (right) served in the navy during World War I and later worked with brother Cliff as business manager of the National Air Races. The brothers also partnered in 1935 to build the Pan Pacific Auditorium (below) in Los Angeles. The Pan Pacific was used for air and auto expositions but is best known for sporting events and entertainment. It also hosted the Ice Follies. The brothers later developed the Pasadena Winter Garden, an indoor ice rink. In the 1940s, the brothers brought their development acumen to the Coachella Valley to create the first resort in their new, planned community. When discussing what to name the new city, brother Randall stated he wanted the word "desert" incorporated. Phil suggested "Palm Desert," and the rest is history. Phil died in August 1946 before the completion of their desert dream.

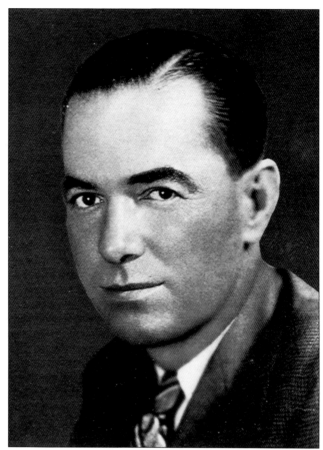

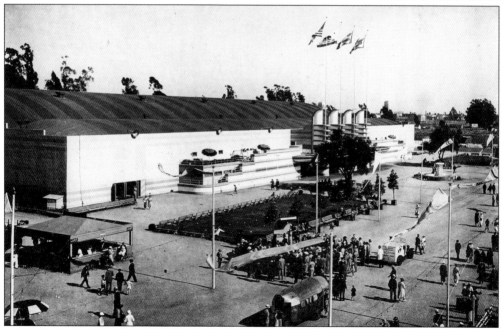

Cliff, the youngest Henderson son, eager to make his mark in the world, traveled west to attend school in Los Angeles. He graduated from Manual Arts High School in 1915, surrounded by schoolmates who would achieve national prominence, including Goodwin Knight, governor of California; Lawrence Tibbets, acclaimed opera star; director Frank Capra; and Jimmy Doolittle, famed pilot. Cliff was noted for his engaging and charismatic personality and determination. He had early success as an organizer and promoter of auto (below) and air races and planned the welcome home event in Los Angeles for the army's "Donald Douglas World Cruisers" round-the-world flight in 1924. The event was a great success, and he next teamed with brother Phil to direct the 1928 National Air Races in Los Angeles.

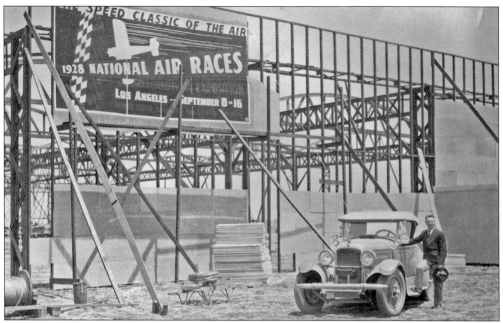

During the early years of aviation, people were fascinated by the concept of flight, and the air shows drew large crowds of celebrities and fans. The 1928 National Air Races in Los Angeles were held in a former bean and barley field that had been developed to accommodate the air races. This airfield was the precursor to Los Angeles Municipal Airport, dedicated in 1930. So successful were the brothers that they became highly sought after air show promoters, managing the National Air Races from 1928 to 1939. Below, from left to right, Cliff Henderson is seen with navy test pilot Al Williams, Charles Lindbergh (early aeronautical pioneer), and Jimmy Doolittle, who had recently won England's Schneider Cup.

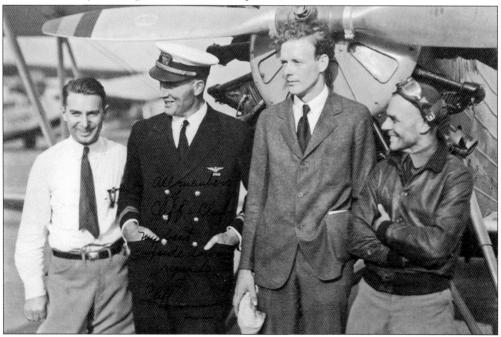

Dorris Henderson was born in 1903, the youngest of the five Henderson siblings and the only daughter. A very energetic girl, she graduated from Manual Arts High School in Los Angeles and attended USC. She adored her older brothers and followed their many varied pursuits with great interest. She married landscape architect Tommy Tomson in 1924 and was busy raising her two daughters when her brothers conceived of building a new city in the desert. Her husband, Tommy, laid out the streets of Palm Desert and designed the layout of the Shadow Mountain Club.

Four

THE SHAPING
OF SHADOW
MOUNTAIN CLUB

With the baby boom underway after World War II, Americans turned their attention to leisure and recreation. The rise of the car culture in the 1950s and improvements to the highway system enabled families to seek adventure in parts near and far. At the same time, the boom in general aviation made long-distance travel more affordable. Attracted by the desert's temperate winter climate and natural beauty, travelers from across the nation discovered the Coachella Valley. Cliff Henderson, eyeing opportunity, formed the Palm Desert Corporation to purchase land in the vacant cove south of Palm Village with the intent of developing a new desert community. This venture was to be centered on a resort—the Shadow Mountain Club—designed to attract people to the area. Seen dumping the first load of ceremonial dirt in July 1946 is Phil Henderson, while his brother Cliff looks on from the driver's seat.

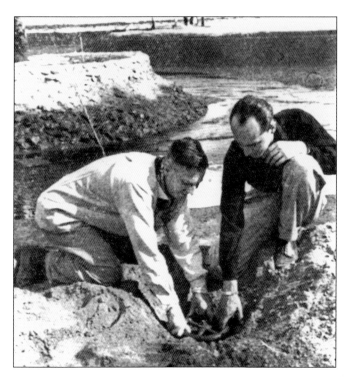

Cliff (left) and Phil Henderson (right) opened the main water valve to the Shadow Mountain Club development. Although the army had drilled wells in the area during their deployment, they had removed them for the steel casings before they left. Cliff knew locating water would be the top priority before building could commence, and he hired Roscoe Moss as well driller. Reportedly, Moss assured Cliff, "We will find it, because as long as there is snow on the mountains there is water in the valley." The first well, drilled just south of El Paseo, reached a depth of 612 feet and was capable of supporting a population of 20,000 people.

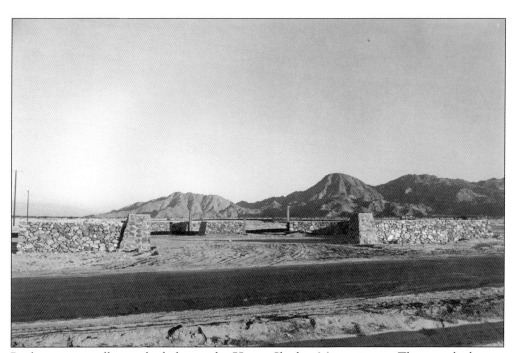

Rock entrance walls were built first at the 75-acre Shadow Mountain site. This view looks east with Eisenhower Mountain the center peak in the background.

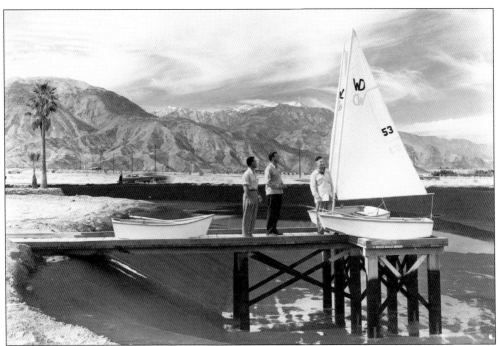

The lake was the first major project undertaken at Shadow Mountain Club and served two purposes—water storage and recreation. Centrally located, it was the first feature visitors saw upon entering the gated property. The lake was 600 feet in length and featured a dock and boathouse, providing sailing and rowing opportunities. The club even hosted miniature regattas. The presence of a large lake surrounded by barren desert was a striking contrast that must have been a remarkable sight for early visitors. The club advertised it had "Hours more Sun, Loads more Fun" to draw visitors out to the new development. Since it was not located directly at the base of the mountains to the west, as is Palm Springs, the club hoped to attract people looking for more hours of daylight.

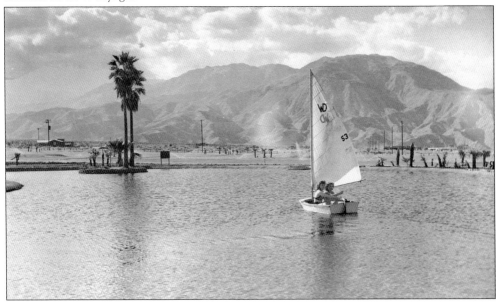

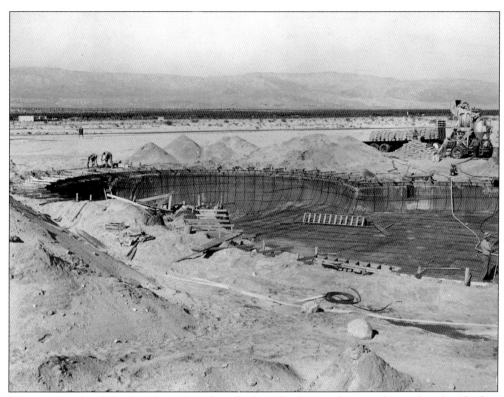

Excavated and stabilized with steel mesh and rebar, the famous figure-eight pool at the Shadow Mountain Club is ready to have cement (gunite) applied. The 130-foot pool was to become the club's entertainment and recreational hub. Without modern equipment, construction was a labor intensive task. The magnitude of the job required enormous quantities of cement. Numerous bags of cement can be seen on, and in front of, the flatbed truck. Mixed on-site with sand, the cement (gunite) was sprayed onto the pool form. With the pool surface finished, the youngster (below) waits for the pool opening. With a capacity of 350,000 gallons of water, filling the pool likely took several days.

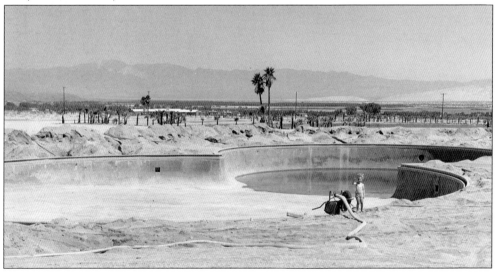

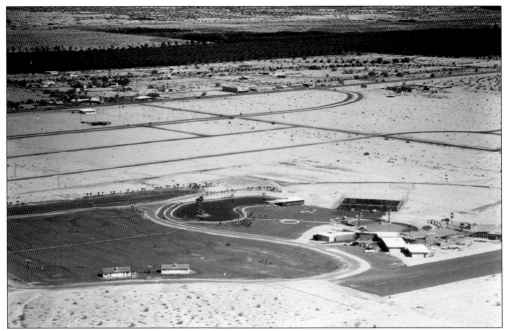

By late 1947, the pool and lake were available for use by members, while construction continued on the clubhouse, dining room, and pro shop. Looking northeast (above) over Shadow Mountain Club, the east end of El Paseo is seen curving to intersect with Highway 111. Construction on the *Desert Magazine* building (to the right of El Paseo) is also underway at this time. Note the numerous date groves still located in Palm Village. Below is a view looking southward toward the mountain coves. It appears the clubhouse is now finished and ready to welcome new members.

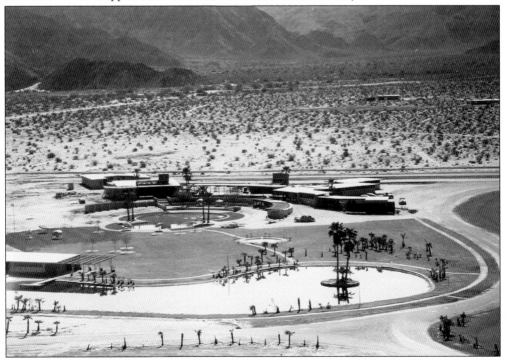

PALM DESERT CORPORATION
OFFICERS AND DIRECTORS

Officers

CLIFFORD W. HENDERSON, President
EARLE R. HUPP, Executive Vice President and
 General Manager
LEONARD K. FIRESTONE, Vice President
PHIL HENDERSON, JR., Treasurer
MARVIN W. MATTHIAS, Assistant Secretary and
 Treasurer

Directors

Clifford W. Henderson Al G. Hill
Leonard K. Firestone Alden Roach
Earle R. Hupp Carl B. Squier
William L. Stewart, Jr. Justin Dart
Phil Henderson, Jr.

SHADOW MOUNTAIN CLUB
OFFICERS AND BOARD OF GOVERNORS

ARTHUR C. STEWART, President
STEPHEN W. ROYCE, Vice President
FRANK W. BIRELEY, Secretary-Treasurer

Directors

Frank W. Bireley
Leonard K. Firestone
Clifford W. Henderson
Stephen W. Royce
Arthur C. Stewart

Board of Governors

Edgar Bergen Dr. John P. Lordan
Frank W. Bireley Alden Roach
Thomas Colby Stephen W. Royce
E. L. Cord Donald Russ
Justin Dart Carl B. Squier
Leonard K. Firestone Lucien Shaw
Clifford W. Henderson Arthur C. Stewart
A. G. Hill William L. Stewart, Jr.
Earle R. Hupp Oscar A. Trippet
Emmett H. Jones Gwynn Wilson
Henry King Raymond R. Wilson
Harold Lloyd

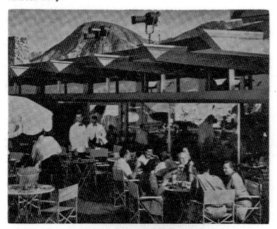

Dining on the Club terrace, in the beautiful main dining room or the colorful Manzanita Room is an unforgettable experience for those who enjoy superb cuisine and enchanting environment.

Cliff Henderson attracted a veritable who's who of prominent men as investors in the Palm Desert Corporation, including Leonard Firestone, Edgar Bergen, Justin Dart of Rexall Drugs, comic actor Harold Lloyd, William Stewart of Union Oil, and Lockheed executive Carl Squier. A total of $250,000 was raised in one evening at Leonard Firestone's home in Beverly Hills as start-up money to purchase the 1,620 acres destined to become Palm Desert. Many of the investors became active members of the Shadow Mountain Club and built some of the earliest homes in Palm Desert. This list of officers appeared in the December 1948 edition of *Sun Spots*, a publication of the club.

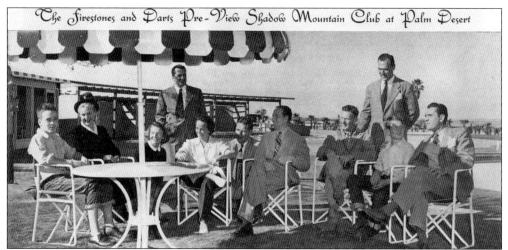

The Firestone and Dart families flew in to have lunch and check on progress at the club. From left to right are (first row) Kimball Firestone, decorator Hazel Wray, Ruth Dart, Polly Firestone, Justin Dart, Leonard Firestone, Cliff Henderson, Brooks Firestone, and club manager Fred Renker; (second row) Mr. Davey, and Carl Tamm.

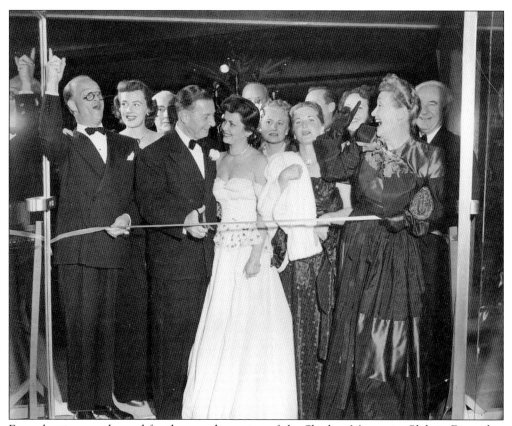

Formal attire was donned for the grand opening of the Shadow Mountain Club in December 1948. A smiling Cliff Henderson is seen cutting the ribbon. To the left is investor and famed ventriloquist Edgar Bergen, while to the right is gossip/society columnist Hedda Hopper.

47

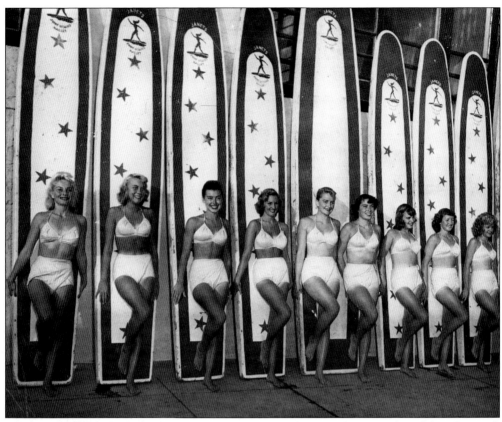

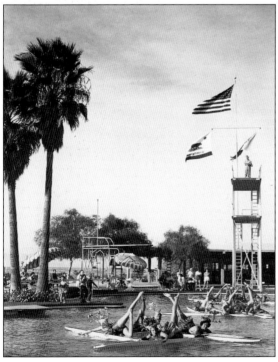

Opening festivities lasted four days and featured prominent aquatic entertainers of the day at the famous figure-eight pool. Janet Dee's Famous Santa Monica Surfboard Ballet Aquacade and Stage Revue performed several acts. During the 1940s and 1950s, Hollywood popularized "aqua musicals" and acts toured the country, leading ultimately to the addition of synchronized swimming as an Olympic sport. Vicki Draves, the first woman in Olympic history to win gold in both the springboard and platform diving in the same Olympics (1948), also performed for the crowd. The diving platform (left) provided an excellent vantage point for photographers to capture the ongoing activities.

Yet another show performed in the pool was by members of the Los Angeles Athletic Club. In their comical attire, they entertained the crowds both day and night with their diving antics. The pool had five championship diving boards that included four springboards and a platform. The pool also played host to the UCLA water polo team during their yearly visit to the club.

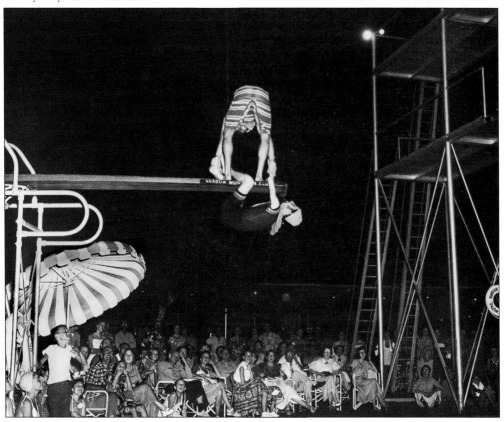

TYPICAL SUMMER MENU

Served 6:00 p.m. to 10:00 p.m.

— HOT SANDWICHES —

$.85

SUPER JUMBO HAMBURGER
POTATO SALAD GARNI
BEVERAGE

$1.65

TENDERLOIN STEAK SANDWICH
POTATO CHIPS GARNI
BEVERAGE

$1.65
HOT ROAST BEEF SANDWICH
POTATO GARNI
BEVERAGE

— SALADS —

SHRIMP SALAD BOWL	1.50
CHICKEN SALAD BOWL	1.45
CHEF'S SALAD BOWL	1.35
CRAB FLAKE LOUIS	1.75
COTTAGE CHEESE SURPRISE	1.35

The above salads served with saltines and beverage

— COLD SANDWICHES —

SLICED TURKEY SANDWICH	.85	COLD SLICED BEEF	.85
CORNED BEEF ON RYE	.75	HAM AND CHEESE	.85
CLUB HOUSE (INDIO)	1.35	LIVERWURST ON RYE	.75
	BAKED HAM	.80	

The above cold sandwiches served with potato salad or slaw

— CHARCOAL BROILED SPECIAL —

$2.25
CHARCOAL BROILED CLUB STEAK
POTATO VEGETABLE
SALAD — ROLLS AND BUTTER
BEVERAGE

$2.25
THICK SINGLE LAMB CHOP
MIXED GRILL POTATO
VEGETABLE — SALAD
BEVERAGE

$3.25
CHARCOAL BROILED NEW YORK STEAK
POTATO VEGETABLE
SALAD — BEVERAGE

$1.85
HALF BROILED CHICKEN
POTATO VEGETABLE
SALAD — BEVERAGE

— DESSERTS —

HALF GRAPEFRUIT .30 CHILLED MELON .35 ICE CREAM .25

SHERBET .25 SUNDAES .35 ASSORTED CHEESE AND CRACKERS .35

— BEVERAGES —

TEA .15 COFFEE .15 MILK .15 ICED TEA .25 ICED COFFEE .20

Activities abounded at the Shadow Mountain Club. While many distant club members chose to visit only during the winter months, there were still a number of local, working residents who stayed in Palm Desert year-round. The restaurant stayed open during the summer of 1955, and this menu displays the dining choices available. Wouldn't it be great to roll back the prices to those of 50 years ago?

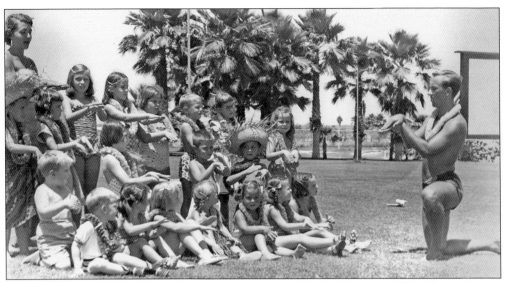

Lou Kuehner was the popular youth activities director at Shadow Mountain Club. Pictured above with assistant Jeanne Hanousek Martin, he is leading children in a Hawaiian dance move. The club offered a variety of activities for children, including swim lessons, folk dancing, tumbling, and evening campfires. During the summer, outdoor films were shown three times a week on a large screen. The movie started at 9:00 p.m. to take advantage of the somewhat cooler evenings. Marionettes provided entertainment at an Easter party (below).

Shadow Mountain Club was initially developed with two tennis courts. With the later addition of lighting, night tennis was a popular way to get in a match year-round. As interest in tennis grew, the club brought in tennis pros for lessons, and tournaments were organized. Pro Magda Rurac (center) congratulates winner Beverly Fleitz (left). Ambidextrous Fleitz was known for playing with two forehands. Today there are 16 courts at the club. Initially a nine-hole golf course was developed for members; in 1959, an 18-hole course designed by Gene Sarazan was opened and remains today. Early duffers walked the golf course until the development of golf carts. The three-wheel cart seen is a very early model.

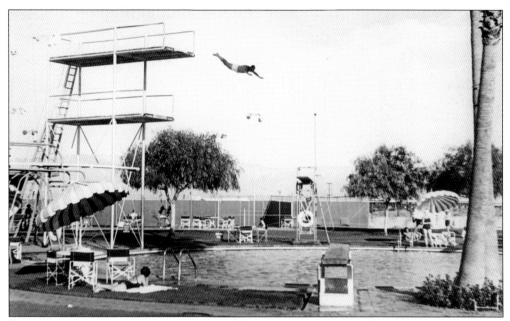

Early aviation personalities frequently visited Shadow Mountain Club, thanks to Cliff Henderson's many personal connections from his days as director of the National Air Races. Dudley Steele, once chief pilot of Richfield Oil Company, moved to Palm Desert in 1951 with severe arthritis in his toes. Like many others who came with health issues, he claimed the desert climate cured him. Seen diving off the platform, Steele was so excited about his newfound health that he challenged other retirees aged 50–100 to a diving contest. It is unknown if any takers accepted his challenge. Below, many people came to watch a synchronized diving exhibition being filmed at the pool. Note the riders on horseback who have stopped to take in the show.

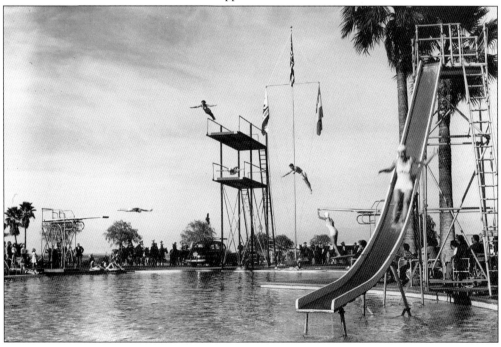

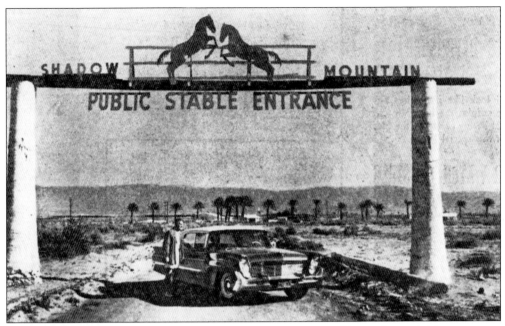

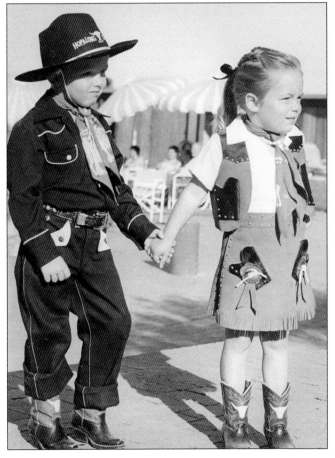

Equestrian activities were plentiful at the Shadow Mountain Stables. Members could rent from the stables or board their horses there throughout their stay at the club. Even early Palm Desert tract maps showed riding trails. For those not interested in taking to the saddle, hay wagon rides, pony carts, and chuck wagon trips were also provided. For the more serious riders, gymkhanas and rodeo competitions were held at the facility; casual riders could take in a morning breakfast ride or barbeque in the local canyons. These children are all decked out in their western attire and ready to hop on a pony. The boy wears an outfit of cowboy Hopalong Cassidy, a very popular television personality during this era. William Boyd, the actor who played Hopalong, later settled in Palm Desert.

(Below) A DELIGHT to all equestrian-minded members is the completion of the new championship turfed three-horse polo field (at left in picture) within the quarter-mile track. The "horsey" crowd has surely come into its own, as evidenced by the unprecedented activity at the Shadow Mountain Stables. Hayrack rides and horseback parties over exciting desert and canyon trails are a source of never-ending enjoyment.

Above, looking east toward the rounded Eisenhower Mountain, the early stables, quarter-mile track, and polo field were initially adjacent to the club. They were later moved to an area by the present-day intersection of Highway 111 and Fred Waring Drive. The Palm Desert Raiders (right) were a riding group that met on Saturday for trail rides. Aptly named, they raided a member's refrigerator each week at the conclusion of their ride. Actor Arthur Lake, who portrayed Dagwood Bumstead in the *Blondie* series of films, is seen with his family in matching Western outfits at the riding arena below.

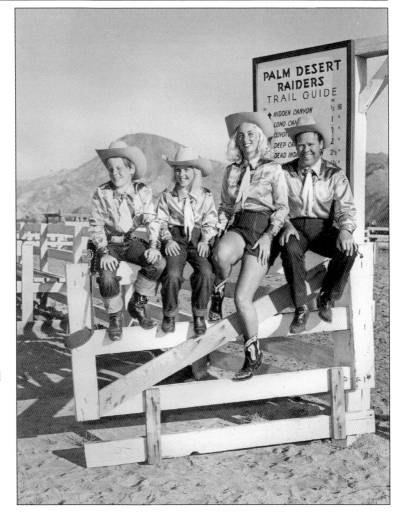

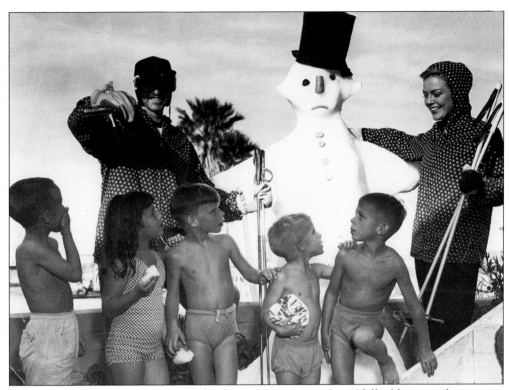

The snow seen here was rushed 40 miles down the mountain from Idyllwild to give these young children a chance to play in snow. Even today, people return from the mountains with snow, as snow only falls on the valley floor every 20 years or so. After the club opening, a rare snowfall hit the valley floor in January 1949, stranding visitors for three days. The adults are decked out for the occasion in ski gear, while the kids happily sample the snow in their bathing suits. Below, children are dressed in their finest for Easter. As Irving Berlin wrote in 1948, "In your Easter bonnet, with all the frills upon it, you'll be the grandest lady in the Easter parade."

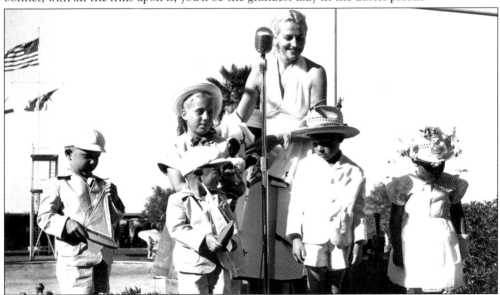

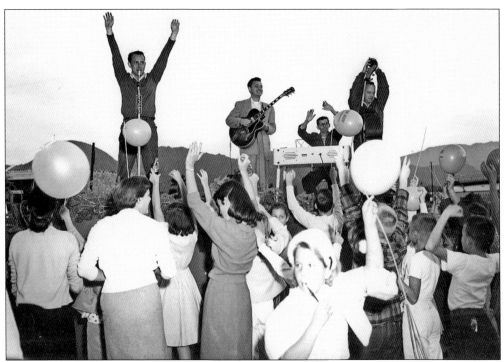

At times, Lou Kuehner entertained young and old alike as the youth activity director. Seen above, he is leading the entertainment at a youth Christmas party. He is pictured below helping members of the Slim and Trim class organize a tumbling routine. Betty Page stands on her head while Kay Malone holds her feet. Jeannette Yoxsimer poses in the front left.

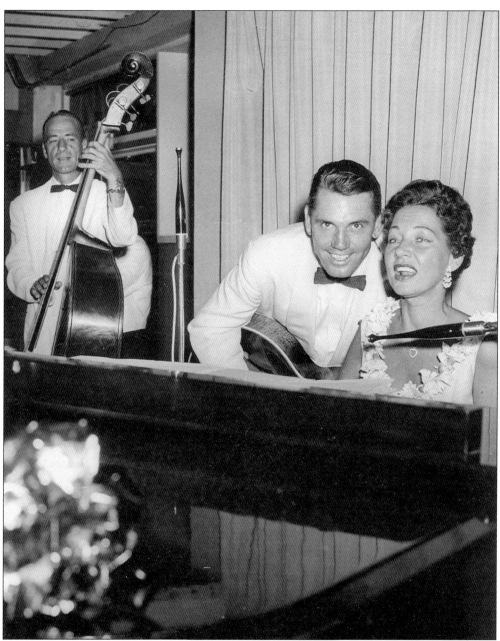

Art and Dottie Todd entertained club members for many years. Dorris Tomson convinced brother Cliff Henderson to hire the singing duo after she and her husband, Tommy, heard them performing at the Miramar Hotel in Santa Monica. In appreciation, the Todds would launch into "My Darling, My Darling," Dorris and Tommy's favorite song, whenever they entered the club. When summer arrived, the Todds traveled to Las Vegas, where they headlined shows at the Dunes and the Sands. They also had a radio show with CBS for five years. Their biggest hit was in 1958 when the romantic song "Chanson D'amour" reached number six on the U.S. charts.

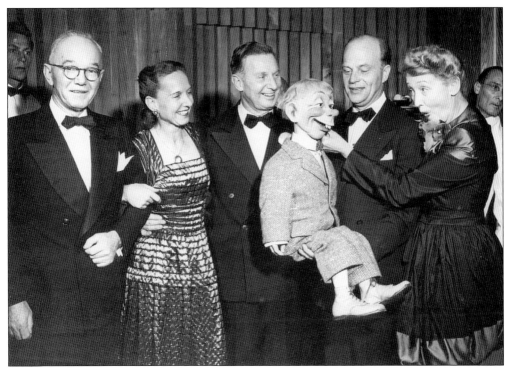

The formal grand opening of the Shadow Mountain Club was a time for the Henderson siblings to celebrate their dream becoming a reality. Here Dorris is flanked by her brothers Randall (left) and Cliff (right). Edgar Bergen and Mortimer Snerd entertain the group, while Hedda Hopper flirts with Mortimer.

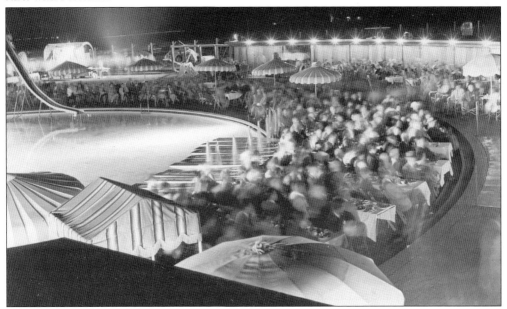

The club terrace was used for both daytime and evening events. The temperate desert climate allowed poolside dining nearly year-round, and shows were frequently performed both around and in the pool.

Leonard Firestone (right) and Cliff Henderson (left) were partners in the Firecliff Lodge, named after the two men, which opened in early 1948. Located only two blocks from the Shadow Mountain Club, Firecliff had rental bungalows, a swimming pool, complete dining, and a cocktail lounge. As there were very few places to stay in the new resort town, many members and guests of the club stayed here. Looking north (below), Firecliff occupied the block between El Paseo and Shadow Mountain Drive, along Larkspur Lane. Although it is vacant in this photograph, the Palm Desert Corporation planned El Paseo to be an upscale shopping street, which over time has come to fruition.

Five

CANYONS, COVES, AND HIGH PLACES

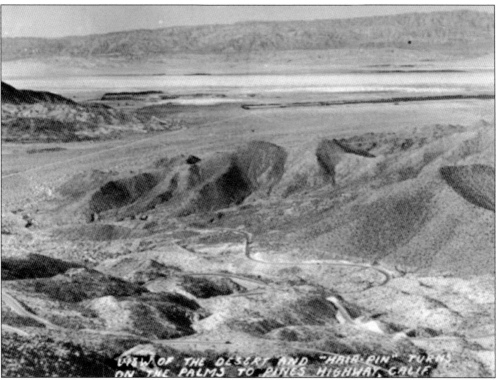

In 1932, Highway 74 was completed from Highway 111 up into the Santa Rosa Mountains, then descending into Hemet. Known as the "Palms to Pines Highway," the road climbs over 4,000 feet in elevation from the palms of the desert to the pines of the San Jacinto Mountain range and offers stunning vistas of the desert. This route offered early residents the shortest distance to the cooler mountain climate. While early travelers viewed the desert as a hostile environment to overcome, later visitors came to appreciate the intense light and stark contrasts of the landscape, and painters and photographers came to capture this uninhabited desert environment in a variety of media. For the more adventurous, the desert's rugged terrain provided a bounty of hikes and riding excursions, many of which were recorded in *Desert Magazine*. However, as growth in the area continued, the desert ecosystem was threatened by human intrusion, dumping, and development. Committed individuals, including Phil Boyd and Randall Henderson, helped establish the foundation for the preservation and appreciation of the desert environment. Their efforts yielded large natural preserves and a better understanding of the environment.

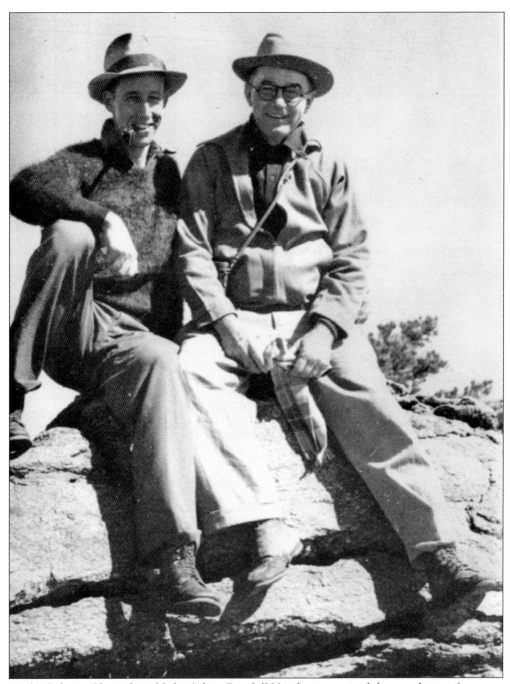

At the *Calexico Chronicle*, publisher/editor Randall Henderson noticed the popularity of reporter J. Wilson McKenney's weekly articles about his desert explorations. They both shared an interest in the outdoors, and during a hike to the peak of Santa Rosa Mountain in 1936, Henderson (right) and McKenney (left) conceived of a monthly magazine dedicated to the Southwestern deserts. McKenney reported that Henderson's vision was to publish a friendly, personal magazine, written for and by people of the desert. Henderson and investors went on to purchase a printing company in El Centro, allowing them to take in commercial print jobs to underwrite their new venture.

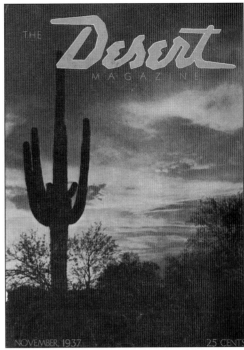

The first issue of *Desert Magazine* (above right) was published in November 1937. While there were only 618 subscribers for the first issue, Henderson and McKenney printed 7,000 copies and distributed them freely to market their new magazine. Today the early issues are collectible items, selling for many times over the first subscription rate of $2.50 per year. Within a year, circulation had increased to 2,400 and continued to grow. After 11 years in El Centro, Henderson moved the publication to Palm Desert. With a broad range of articles (left), readers could always find an interesting story to peruse in *Desert Magazine*. Moreover, true to Henderson's concept of a magazine by and for people of the desert, readers were invited to submit articles and photographs for publication.

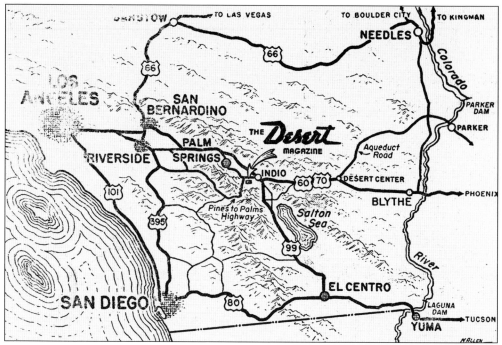

By 1945, Randall Henderson was looking to relocate his printing business and *Desert Magazine* from El Centro to a more remote desert area with easy highway access yet room for growth. Randall teamed with his brothers Cliff and Phil and selected a vacant cove 12 miles east of Palm Springs. Fittingly, the cove was at the base of the Santa Rosa Mountains, where the idea of *Desert Magazine* was first conceived.

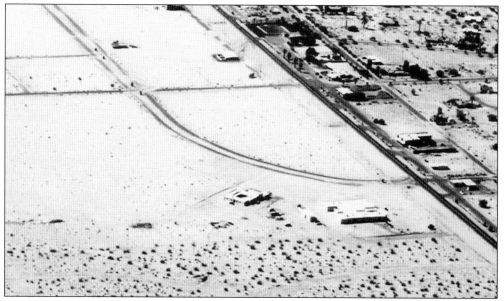

The *Desert Magazine* building was constructed on a 20-acre site at the east end of El Paseo, at its juncture with Highway 111. To the left of the *Desert Magazine* building is a seven-unit apartment complex. As housing was limited at the time, Randall had the apartments built to house his employees. This building today is home to Jillian's restaurant at 74-155 El Paseo.

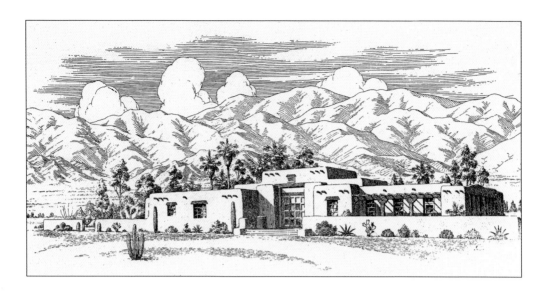

Artist and cartographer Norton Allen's rendering of the *Desert Magazine* building (above) shows its Southwest pueblo-style architecture. As seen below, the finished building closely replicates the early sketch. The building and adjacent apartments were designed by Palm Springs architect Harry J. Williams and constructed by R. P. Shea of Indio. Completed in 1948, it was the first major structure south of Highway 111. The 17,000-square-foot building not only housed the business offices and printing facilities, but also the Desert Southwest Art Gallery. Still located at 74-225 Highway 111, this easily identifiable historical building is currently home to L. G.'s Prime Steakhouse.

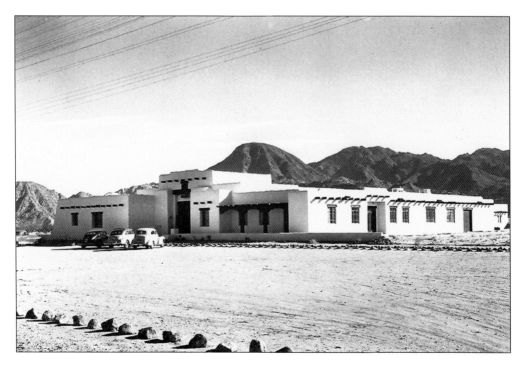

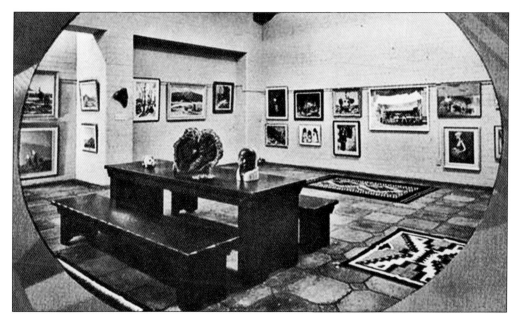

Besides housing the publishing and printing business, the *Desert Magazine* building was also home to an art gallery and bookstore. At nearly 2,000 square feet, the gallery featured many noted artists and also sold rugs, sculpture, gems, and crafts—all related to the desert. Henderson felt strongly that cultural endeavors could successfully coexist with his commercial magazine, and he encouraged the arts in the newly developing town of Palm Desert.

At right is John Hilton, well-known artist and equally accomplished gemologist, miner, geologist, botanist, guitarist, singer, and writer. Upon advice from Maynard Dixon, Hilton switched from using a brush to a palette knife. Hilton painted a large mural in the Desert Southwest Art Gallery and also wrote nearly 100 articles for *Desert Magazine*. Seen with Hilton is Bill Bender, another desert artist who got his start traveling with fellow artist Jimmy Swinnerton.

This August 1948 issue of *Desert Magazine* was the first one published at the new facility in Palm Desert. It featured Tahquitz Canyon Falls, in neighboring Palm Springs, on the cover. The greeting "Friend or Stranger, You Are Welcome Here" hung over the entrance to the *Desert Magazine* building and came to symbolize the manner in which the building embraced residents and travelers alike. The building was open seven days a week, and travelers would often stop to admire the architecture, view the gallery, and even purchase a keepsake. By the time Henderson sold the magazine in 1958 to Charles Shelton, subscriptions had grown from 600 to over 30,000, and it was being mailed to readers in all 48 states, as well as abroad.

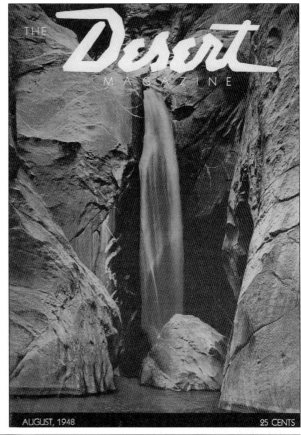

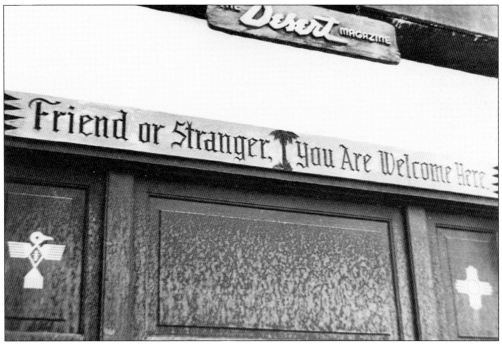

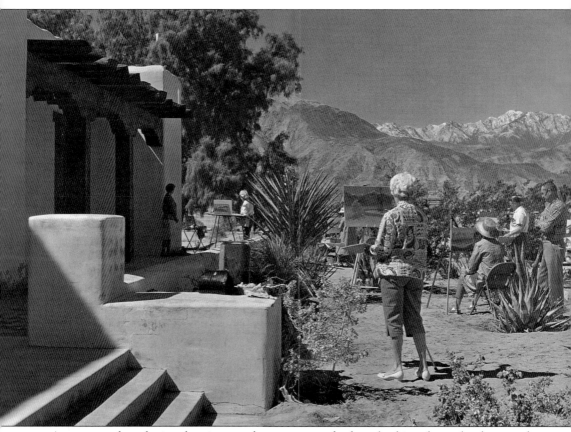

Amateur and professional artists sought to capture the breathtaking desert landscapes that surrounded them. Pictured here in 1962 is a weekly class conducted by Sterling Moak (right) outside the *Desert Magazine* building. En plein air (French for "in the open air") desert artists were able to paint nearly year-round in the temperate climate. Taking their easels outdoors, the artists attempted to capture the ever-changing light and moods of nature. The Desert Southwest Art Gallery featured noted desert artists such as John Hilton, Fred Chisnall, Olaf Wieghorst, Sam Hyde Harris, Ted DeGrazia, Orpha Klinker, Clyde Forsythe, Wilton McCoy, Peter Hurd, and Henriette Wyeth. Local artist Carl Bray had a painting featured on the cover of *Desert Magazine*.

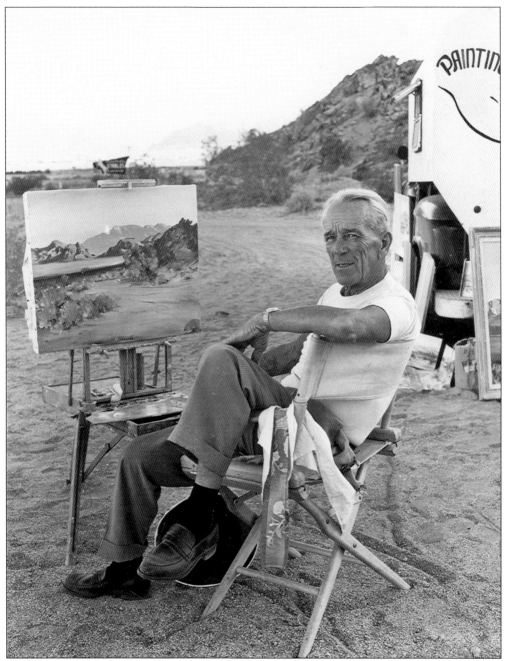

As automobiles and trains made the desert easily accessible in the 1920s and 1930s, more people, including artists, began arriving in the Coachella Valley. One such artist was Frederick Chisnall, seen here at Painters Path, an area that attracted plein air artists. The moderate desert weather allowed artists to paint nearly year-round; however, many would leave to cooler climates during the summer. For a time, Chisnall lived in his trailer at the site, selling his paintings to travelers along Highway 111. He shared the cove with Andy the Donkey Man and "rockologist" Chuckawalla Slim. The area was located near present-day Moller's Garden Center on appropriately named Painters Path.

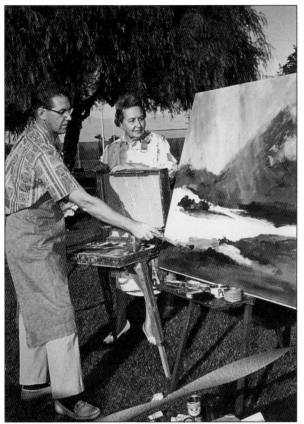

Evie Chevoor, a hostess at Shadow Mountain Club, became interested in painting after she was given instruction by Fred Chisnall. When she displayed her first work at the club, members commented they would also like to learn to paint. Noting this interest, Irene Fenton (left) cofounded the Shadow Mountain Palette Club with Thirza Schenk in 1961. Fenton, already an accomplished artist, had previously traveled to Europe to study with artists overseas. Under her guidance, the Palette Club flourished, attracting both skilled and beginning artists. The club even offered field trips to canyons around the valley so members could gain varied experiences. Here she admires a work in progress of Val Samuelson. With monthly meetings featuring guest artists such as John Hilton and juried competitions, membership grew. "Little Bit of Paris," the first poolside painting party of the 1964 season (below) attracted over 200 members.

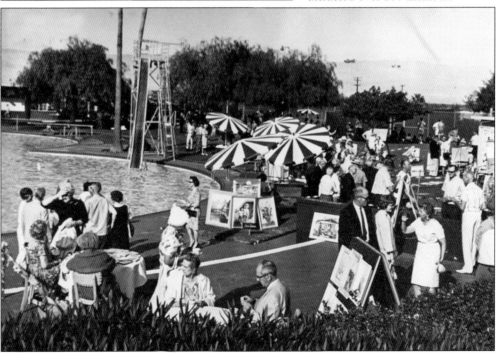

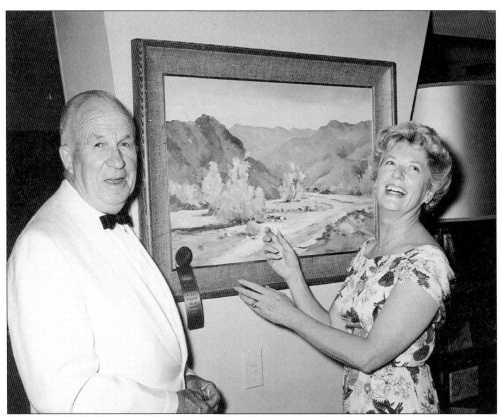

Artists and Palm Desert residents Fred and Paula Penney lived in the desert over 30 years. Fred, a charter member of the Shadow Mountain Palette Club, specialized in desert landscapes and painted with both oils and watercolors. He was a member of both the Shadow Mountain Palette Club and the Desert Art Center in Palm Springs.

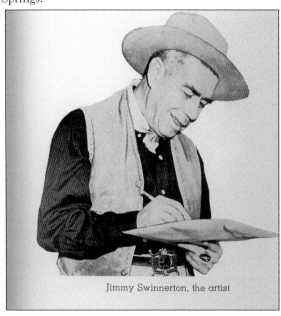

Jimmy Swinnerton, the artist

Early in his career, Jimmy Swinnerton worked for publisher William Randolph Hearst and was best known for his cartoon *Little Jimmy*. Like many others, he came to the desert to improve his health. After recovering from tuberculosis, Swinnerton began exploring the area. As he discovered the beauty of the desert, he sought to capture the landscape on canvas. His painting skills developed over the remainder of his life, and he died in Palm Desert at the age of 98.

Philip Boyd (left), an early rancher, was the first mayor of Palm Springs in 1938. In the late 1930s, Boyd purchased about 270 acres of desert south of Palm Village. After the war, Boyd developed a small nursery on his land and grew native *Washingtonia Filifera* palms; however, he kept his remaining land undeveloped. As more people began exploring the nearby desert, Boyd was distraught to see the damage they caused and the trash they left strewn about. In 1952, he and Randall Henderson discussed establishing a natural area that could be fenced in for protection. They convinced the Palm Springs Desert Museum to lease additional land from the water district and established the Wildlife Sanctuary, part of what is now The Living Desert.

The Wildlife Sanctuary on Portola Avenue was left undeveloped, except for the creation of a nature trail and an oasis. Although a sign at the gate encouraged visitors to respect the property, the area was being abused and it became apparent that the sanctuary needed a custodian. In the late 1960s, The Living Desert Association was formed to further develop and protect the sanctuary, and in 1970, biologist Karen Sausman (below) became the first employee. Sausman shared Boyd's vision of the desert and developed The Living Desert into a world-class facility dedicated to preservation, education, propagation, and research. She retired as executive director in 2008.

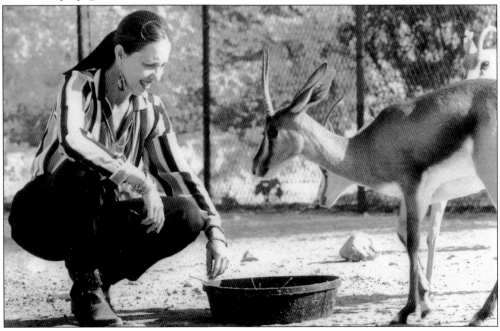

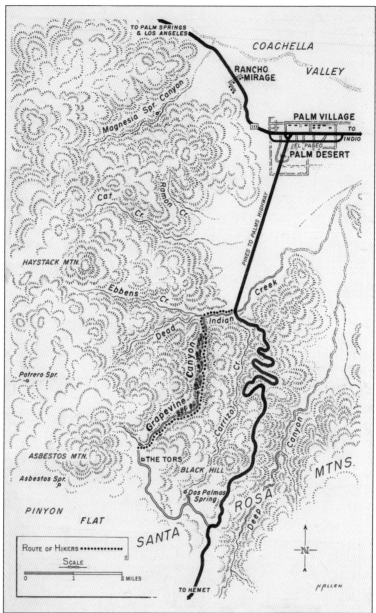

This 1947 Norton Allen map of the Palm Desert cove depicts the numerous canyons that flow out of the Santa Rosa Mountains into the alluvial fan south of the city. These canyons were explored by Randall Henderson, and seven of his treks were memorialized in *Desert Magazine.* "Rope Down and Swim Out" (November 1938 issue) spoke of his descent down Deep Canyon, the cavernous gorge east of Highway 74. Henderson concluded that "for sheer rugged grandeur Deep Canyon . . . rank[s] as one of the most impressive scenic areas in the Desert Southwest. And I am sure it will never be crowded with traffic." Twenty years later, Philip Boyd ensured Henderson's prophesy by donating 1,500 acres of land he owned at the entrance to Deep Canyon to UC Riverside, which established a research center there. Clearly seen on the map is the portion of Highway 74 known as "Seven Level Hill," which makes seven switchbacks on the face of the mountain.

In addition to donating his land for the research center, Philip Boyd provided funds to purchase three adjoining sections of land to be included in the center. The research area has since grown to over 16,000 acres and extends in elevation from 400 feet in the cove to 4,600 feet in the mountains. Now part of the University of California Natural Reserve System, the facility offers research opportunities to faculty and graduate students; however, it is closed to the public. To commemorate the 100th anniversary of the University of California, Ansel Adams (right in an image captured by Lloyd Tevis) was commissioned to photograph UC sites around the state. He took over 200 photographs in Deep Canyon, two of which are included in *Fiat Lux*, the anniversary book of the university.

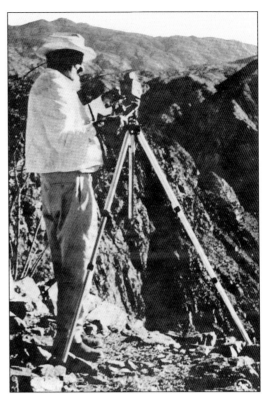

Written by founders Randall Henderson and J. Wilson McKenney, this essay appeared in their first issue of *Desert Magazine* in 1937. Their words reflect their view of the desert:

There are Two Deserts: One is a grim desolate wasteland. It is the home of venomous reptiles and stinging insects, of vicious thorn-bearing plants and trees, and of unbearable heat. This is the desert seen by the stranger speeding along the highway, impatient to be 'out of this damnable country.' It is the desert visualized by those children of luxury to whom any environment is unbearable which does not provide all the comforts and services of a pampering civilization. It is the concept fostered by fiction writers who dramatize the tragedies of the desert for the profit it will bring them.

Henderson and McKenney continue:

But the stranger and the uninitiated see only the mask. The other Desert—the real Desert—is not for the eyes of the superficial observer, or the fearful soul or the cynic. It is a land, the character of which is hidden except to those who come with friendliness and understanding. To these the Desert offers rare gifts: health-giving sunshine—a sky that is studded with diamonds—a breeze that bears no poison—a landscape of pastel colors such as no artist can duplicate—thorn-covered plants which during countless ages have clung tenaciously to life through heat and drought and wind and the depredations of animals, and yet each season send forth blossoms of exquisite coloring as a symbol of courage that has triumphed over terrifying obstacles.

To those who come to the Desert with friendliness it gives friendship; to those who come with courage, it gives new strength of character. Those seeking relaxation find release from the world of man-made troubles. For those seeking beauty, the Desert offers nature's rarest artistry. This is the Desert that men and women learn to love.

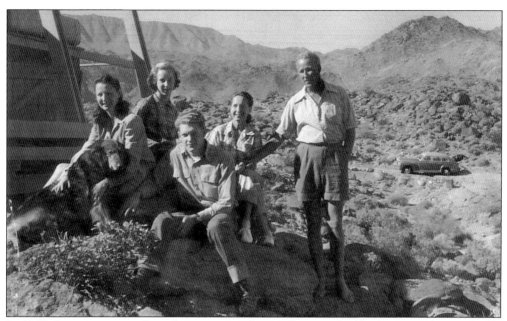

In 1945, the government allowed citizens to stake out 5-acre jackrabbit homesteads in Cahuilla Hills for a mere $5 per year. Upon improving the land with a cabin valued at $300 or more, the homesteader earned the deed to his claim. "Cabin in the Hot Rocks . . ." appeared in the March 1949 issue of *Desert Magazine*. It chronicled the efforts of the Tomson family to build their cabin in the hills west of Highway 74. Tommy (far right), who laid out the streets of Palm Desert, constructed the cabin out of railroad ties. While there was no electricity and water had to be hauled in, the view was amazing and the family frequently spent weekends at the cabin. To his right is his wife, Dorris, daughters Duchess and Kay (with dog Barron), and Kay's husband, Walt Eichenhofer.

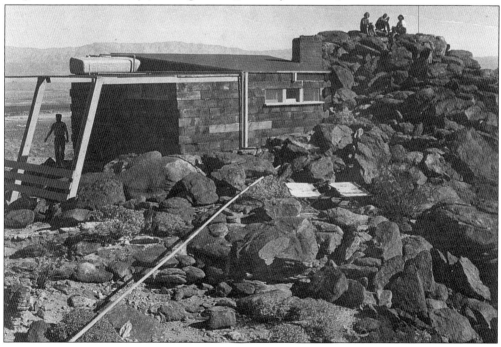

Six

BUILDING A
COMMUNITY

The construction of the Shadow Mountain Club and *Desert Magazine* facilities kicked off a building boom in the master-planned development of Palm Desert. Lots were purchased, and construction began on both homes and commercial buildings. New businesses moved in to provide services to the growing population, and the communities of Palm Village and Palm Desert were united in 1951—taking the name Palm Desert. Growth remained steady, and soon Palm Desert contained all services necessary to support a community, including a post office, school, church, fire department, and library. Over time, the growing community was billed as many things: "Something New Under the Sun," "The Smartest Address on the American Desert," and "The Vacation Golf Capital of the World."

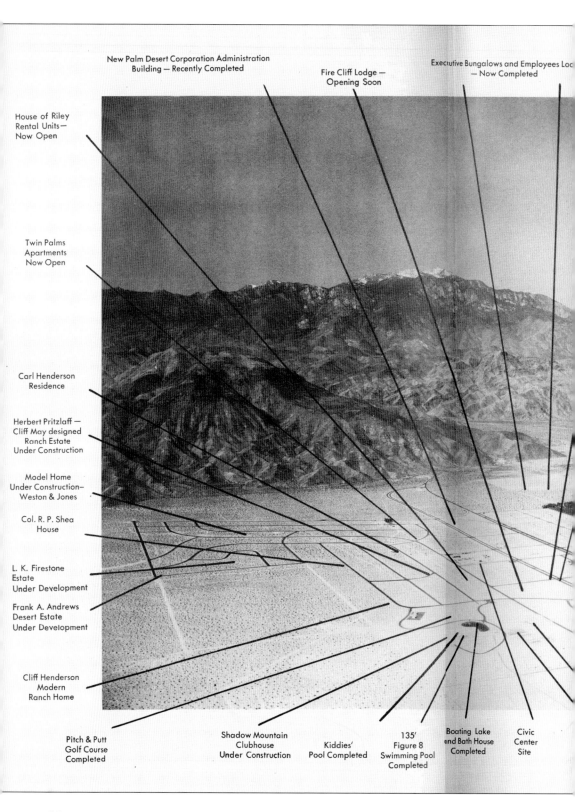

New Palm Desert Corporation Administration Building — Recently Completed

Fire Cliff Lodge — Opening Soon

Executive Bungalows and Employees Loc — Now Completed

House of Riley Rental Units— Now Open

Twin Palms Apartments Now Open

Carl Henderson Residence

Herbert Pritzlaff — Cliff May designed Ranch Estate Under Construction

Model Home Under Construction— Weston & Jones

Col. R. P. Shea House

L. K. Firestone Estate Under Development

Frank A. Andrews Desert Estate Under Development

Cliff Henderson Modern Ranch Home

Pitch & Putt Golf Course Completed

Shadow Mountain Clubhouse Under Construction

Kiddies' Pool Completed

135' Figure 8 Swimming Pool Completed

Boating Lake and Bath House Completed

Civic Center Site

80

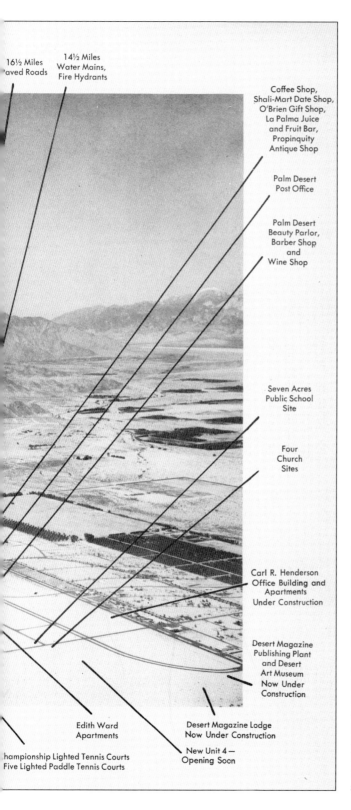

16½ Miles Paved Roads

14½ Miles Water Mains, Fire Hydrants

Coffee Shop, Shali-Mart Date Shop, O'Brien Gift Shop, La Palma Juice and Fruit Bar, Propinquity Antique Shop

Palm Desert Post Office

Palm Desert Beauty Parlor, Barber Shop and Wine Shop

Seven Acres Public School Site

Four Church Sites

Carl R. Henderson Office Building and Apartments Under Construction

Desert Magazine Publishing Plant and Desert Art Museum Now Under Construction

Edith Ward Apartments

Desert Magazine Lodge Now Under Construction

Championship Lighted Tennis Courts Five Lighted Paddle Tennis Courts

New Unit 4 — Opening Soon

This early aerial from 1947 looks west across vacant Palm Desert toward Mount San Jacinto. The many notations in the margin point to where future development would be occurring, now that the streets had been constructed. In keeping with his love of the desert, Randall Henderson recommended the names of desert trees, plants, and flowers that could serve as street names in the new community. Joshua Tree Street, Ocotillo Drive, Goldenrod Lane, and other street names make it clear many of Henderson's suggestions were accepted.

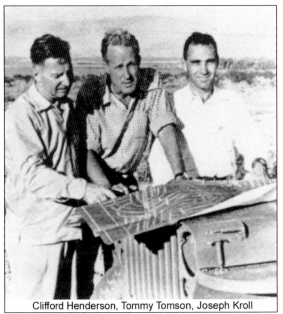

Cliff Henderson (left), landscape designer Tommy Tomson, and construction engineer Joseph Kroll (right) examine the street plan for Palm Desert. As surveyors laid out the streets in 1946, they discovered the area formerly occupied by the army to be so compacted that they had to use an 8-pound sledgehammer and steel gads to make pilot holes for the redwood stakes.

Clifford Henderson, Tommy Tomson, Joseph Kroll

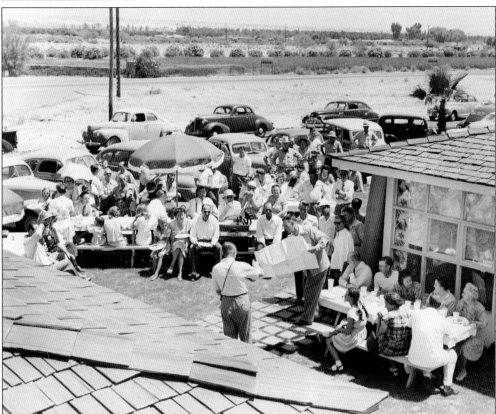

Palm Desert Corporation paved over 16 miles of roads and laid 14 miles of water mains for its subdivision. A large crowd gathered on November 6, 1946, the first day the lots were offered for sale. Within two weeks, over $200,000 worth of property had been sold.

Due to the number of subscriptions that would be mailed from the relocating *Desert Magazine*, the federal government agreed to open a post office in Palm Desert. The flag was raised on July 14, 1947, with World War II marine veteran William Meyers serving as the first postmaster. The new post office meant local residents no longer needed to travel to Indio for mail service.

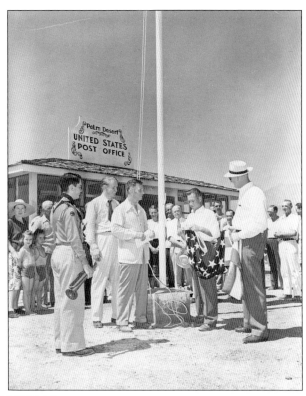

When Gertrude Keedy arrived with her husband, Bob, in 1945, they had one daughter, Barbara. On April 5, 1947, their son Doug was the first child born to a resident of Palm Village. Bob Keedy was the area's first grocer and later opened Keedy's Fountain and Grill in 1957. The restaurant remains open and is a longtime favorite of locals.

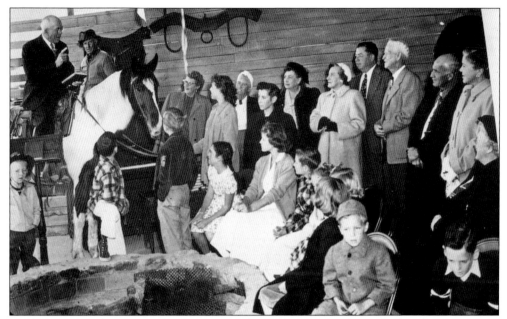

As there was no place to worship between Cathedral City and Indio, early church services were held at the Shadow Mountain Club stables. Seen delivering his own "sermon on the mount" is Rev. John Robertson Macartney. Macartney, a resident of Palm Springs, came out of retirement to pastor the new church.

A block of land on Portola was donated by the Palm Desert Corporation as the site of the first community church. The first service at the site was held on Thanksgiving Day 1948, with 109 worshippers in attendance. Until a church was built in 1951, members of the newly formed Palm Desert Community Church worshipped on the site, with a temporary altar and simple benches brought in for the services.

Reverend Macartney said, "It takes Grace, Grit, and Greenbacks to build a church. God will provide the Grace. Your leader has a good stock of Grit, and you, the people, must furnish the Greenbacks." In 1949, the Building Committee, chaired by Carl Henderson, was formed and appealed to parishioners from the surrounding communities for support.

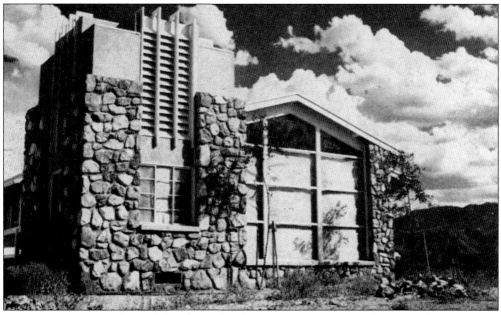

Architect Barry Frost donated the plans, church members helped clear the site, and construction commenced on the building. Completed in 1951, the building was oriented to take advantage of the view of Mount San Jacinto through the chancel window. With a locomotive bell donated by the Union Pacific Railroad, the congregation was called to worship. The building, still home to a church, is at 45630 Portola Avenue.

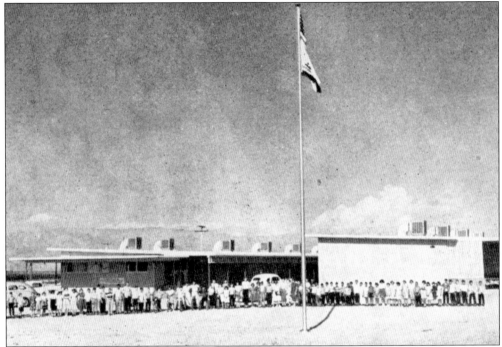

Children of the early Palm Village and Palm Desert residents traveled 10 miles east to attend school in Indio. As the community grew, a local school was needed to serve the residents. Palm Desert School opened its doors in September 1949 to children in grades kindergarten through eight (above). This school was demolished in 2005 to make way for the larger, two-story Washington Charter School at 45768 Portola Avenue. In the 1950s, a common school celebration on May Day was dancing around the maypole. Here children interlace their ribbons with their classmates to decorate a maypole.

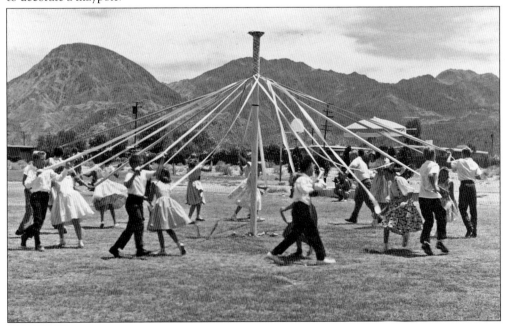

A volunteer fire department was formed to protect the community. Grocer Bob Keedy was designated fire chief, with Kay Olesen as captain. Many members of the original Palm Desert Volunteer Fire Department are seen at their first community fund-raiser, held at the Shadow Mountain Club in 1949. The event attracted over 700 people.

In 1950, resident Ole Olesen, known for his hit Broadway show and movie *Hellzapoppin'*, donated his time and talent for the fund-raising effort to purchase fire equipment.

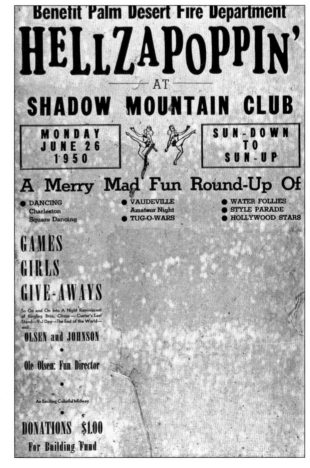

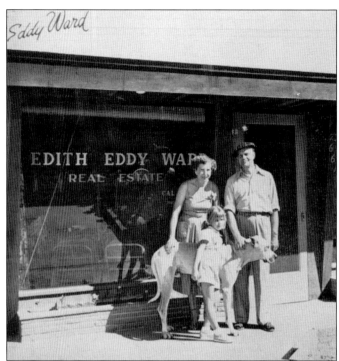

Seen in 1950 outside her new office at the Patio Shops, the first business complex in Palm Desert, is realtor Edith Eddy Ward. Arriving to the area in 1946 as sales manager of the Palm Desert Corporation, Ward was key to the early success of the development. Seen with Ward is a young Candy (Candice) Bergen on hand to cut the ribbon to the complex. She is accompanied by her father and Cliff Henderson's Great Dane.

Another business in the Patio Shops was the Palm Desert Pharmacy, run by Ed Mullins, which had a small soda fountain. In 1957, Bob Keedy, seen behind the counter, expanded the building and purchased the soda fountain from Mullins. Keedy's Fountain and Grill continues in the same location today at 73633 Highway 111.

Not only did William Boyd ("Hopalong Cassidy") live in Palm Desert, but he was also a local businessman. In addition to several apartment complexes he owned, Boyd also built a commercial building next to the Patio Shops. Seen with realtor Dick Coffin (left), builder Bill Phillips (right), and future tenant Ralph Hale (in shorts), Boyd's building was painted his signature colors of black and white.

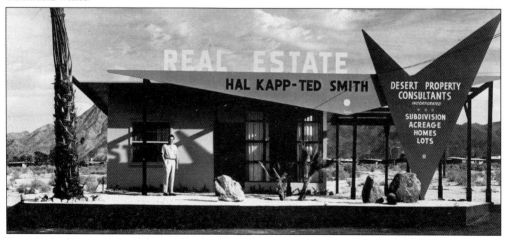

In 1953, Hal Kapp arrived during the building boom in Palm Desert and joined with Ted Smith in a real estate business. Kapp quickly became involved in the emerging community and was the president of the chamber of commerce for four years, on the community library association for 10 years, Rotary president, and the first president of the Historical Society of Palm Desert in 1977.

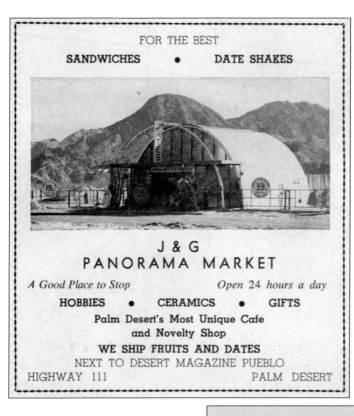

FOR THE BEST

SANDWICHES • DATE SHAKES

J & G
PANORAMA MARKET

A Good Place to Stop Open 24 *hours a day*

HOBBIES • CERAMICS • GIFTS

Palm Desert's Most Unique Cafe
and Novelty Shop

WE SHIP FRUITS AND DATES

NEXT TO DESERT MAGAZINE PUEBLO

HIGHWAY 111 PALM DESERT

Following World War II, building supplies were extremely difficult to obtain and many new businesses were started in war surplus buildings transported to the area. The J&G Panorama Market was located in a Quonset hut. Located just east of the *Desert Magazine* building and open 24 hours a day, the market provided refreshment, including date shakes, to weary travelers both day and night. The hut, now covered with stucco, still exists at 74271 Highway 111.

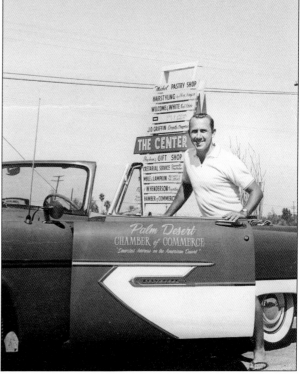

As the town continued to grow, a chamber of commerce was formed to promote the new businesses. In 1957, Lou Kuehner left his position at Shadow Mountain Club to become the first paid manager of the chamber. Seen outside the new chamber office, Kuehner is standing next to his Plymouth Belvedere convertible, complete with side door monikers.

Edith Morrey's dress shop was the second business on El Paseo. Her husband, Robert Morrey, M.D., had an office in the same building. Perhaps his most notable patient was President Eisenhower, who claimed the doctor cured his sore shoulder, cementing their friendship. Eisenhower's limousine could be seen outside the dress shop when he stopped by to socialize with Dr. Morrey. The Morreys (right) are dining with Adrian and Mercedes Schwilck, developers of Silver Spur Ranch.

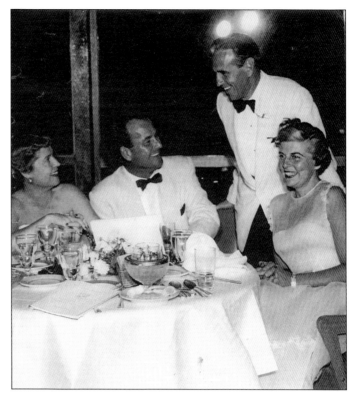

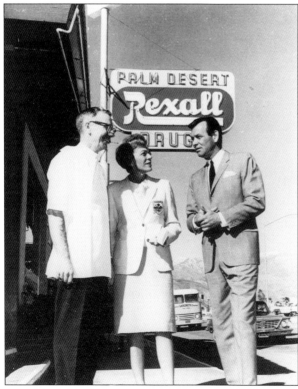

In 1966, honorary mayor and actor David Janssen (right), of *The Fugitive*, paid a visit to the Palm Desert Pharmacy to purchase vitamin C from pharmacist Ed Mullins (left). Mary Kay Van de Mark, of the chamber of commerce, is seen between the two men.

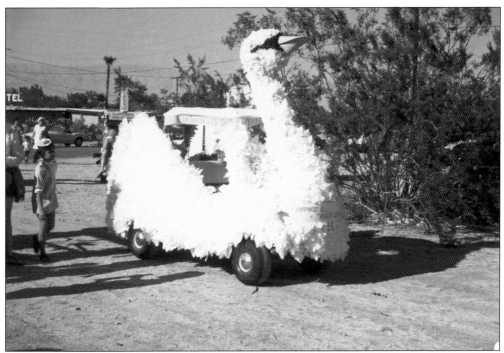

Looking to create a fun atmosphere for the residents still here in the summer of 1963, Hilma Lawrence, manager of Firecliff Lodge, suggested to the local service clubs they host a "Christmas in July" golf cart parade. The event was an immediate hit and continues to this day. However, at the request of local clergy, it was renamed the Midsummer Madness Golf Cart Parade in later years.

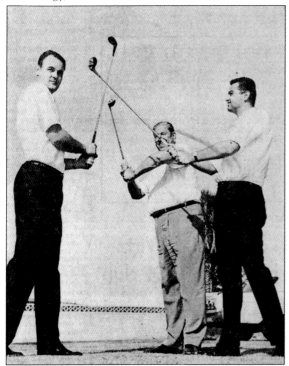

Seen fencing with their golf clubs are, from left to right, Jim Anderson, Thoral Lake, and Bob Ricciardi. They are practicing for the Service Club Golf Classic of 1965. Ricciardi was the president of the Palm Desert Jaycees, a service group of young men in the community. They were instrumental in the development of the first park in Palm Desert—Community Park on Magnesia Falls.

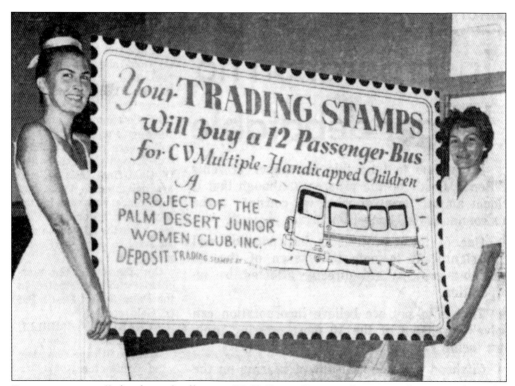

Does anyone recall the days of collecting S&H Green Stamps? As a reward program from the 1930s to the 1980s, trading stamps, given out by businesses, were collected in books then redeemed for products. In 1966, the Palm Desert Junior Women's Club undertook the tremendous project of collecting 1,500 books to purchase a bus for the disabled. Ronnie Richardson (left) and Carol Barfknecht display their sign.

Early children in the area had to travel to Indio to participate in organized sports. As more families moved to the area and the population of Palm Desert grew, civic groups like the Rotary Club sponsored local teams, including some of the boys seen here.

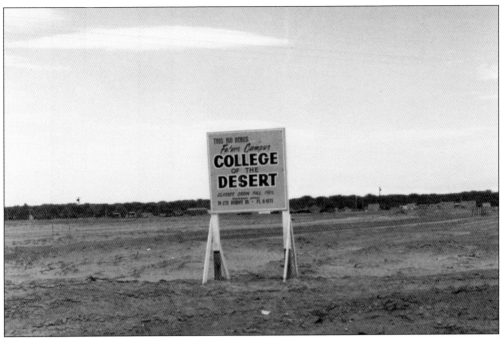

By the late 1950s, valley leaders discussed the need for a junior college to advance educational opportunities for local children. Centrally located Palm Desert was chosen as the best site for a college, and 120 acres of land were purchased from rancher Amos Odell at the northeast corner of Monterey Avenue and Fred Waring Drive. Building commenced in 1961, and the college welcomed its first students in the fall of 1962.

Architect John Carl Warnecke of San Francisco designed the campus, with notable local architects contributing on the various buildings, including John Porter Clark, Albert Frey, Don Wexler, Robson Chambers, and Stewart Williams. Initially the Odell ranch home was occupied by the first president of the college, Roy McCall. Now known as the Velma Dawson house, the former home houses the alumni association.

The College of the Desert Faculty Women's Club was not only active socially but also raised funds for student scholarships. Seen at this family outing are, from left to right, Pat McDermott and son Evan, Jan Thompson with daughters Traci, Tommi, and Terri, and Mrs. Ronald Remington with son Lennie.

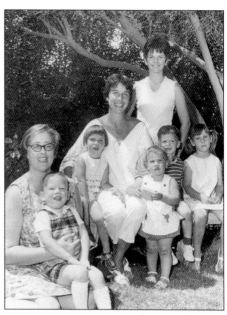

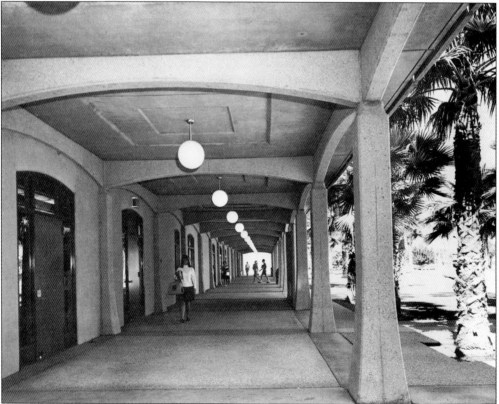

Architect John Warnecke claimed that, during a visit to the desert to examine potential sites for the college, he was drawn to the beautiful symmetry of the nearby date groves. His design reflects that observation, with the arching columns mimicking palms and the shaded arcade protecting students traveling between classes.

In 1950, Clay Stearns, retired actor and dancer, organized a community theater group. Many thespians of the community participated in the local productions, which were held at the Playhouse at 73550 Santa Rosa Way, now the Desert Torah Academy. The curtain was painted by Margo Gerke Ernst. In the center, she depicted "Washington Crossing the Delaware" surrounded by local merchants' advertisements.

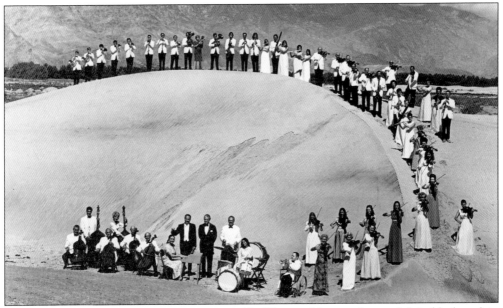

The Desert Symphony Association was started by Thomas Mancini (center left in black tux) in the mid-1960s as the result of an evening music class he taught at College of the Desert. Many members of the community participated, including fire chief Jim McClellan with his oboe. Guest conductors included Jack Benny, Tennessee Ernie Ford, and Red Skelton (center right in black tux), seen with the orchestra on a sand dune near Cook Street.

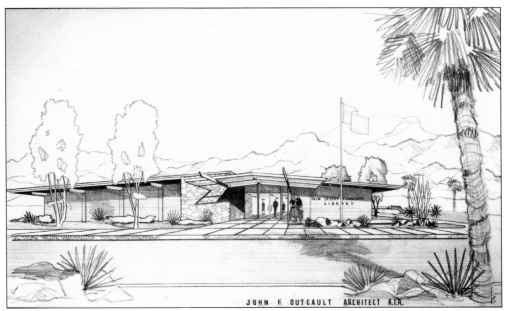

JOHN F. OUTCAULT ARCHITECT A.I.A.

In the mid-1950s, the Palm Desert Community Library Association rented space in one of the early Patio Shops. As the community outgrew this small site, land was donated by Randall Henderson for the construction of a library building. Local architect John Outcault donated his time to design the modern building, and residents contributed to the building fund. Opened in 1963, the building is now the community center located at 45580 Portola Avenue.

After several unsuccessful attempts at incorporation, Palm Desert residents voted to approve cityhood in November 1973. With 2,513 "Yes" votes to 683 "No" votes, Palm Desert became the 17th city in Riverside County. Of the 20 candidates who ran, the top five vote recipients were selected as council, with top vote-getter Hank Clark becoming mayor.

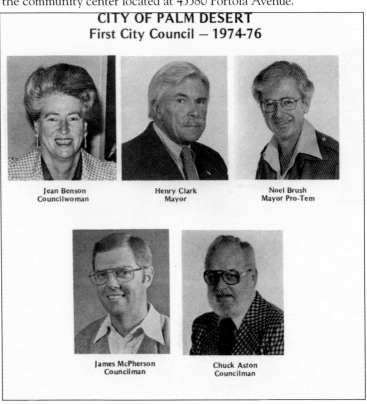

CITY OF PALM DESERT
First City Council — 1974-76

Jean Benson
Councilwoman

Henry Clark
Mayor

Noel Brush
Mayor Pro-Tem

James McPherson
Councilman

Chuck Aston
Councilman

97

Hurricane Kathleen wreaked havoc in Palm Desert in September 1976. As floodwaters ran off the Santa Rosa Mountains to the south, torrents of water raced through the city. With Portola Avenue a virtual river and the Whitewater Wash cresting, the street was undermined and collapsed. Fortunately, storm channels and drainage have since been built to protect the city, and a bridge recently completed here ensures a safe trip across the wash.

The first Boy Scout troop in Palm Desert was sponsored by Jerry Malone, owner of the Union 76 gas station. Fittingly, they were named Troop 76. These two scouts, Larry Krikorian (left) and Robert Pitchford (right), attained the highest rank of Eagle Scout in July 1978.

Many early desert homes were designed with large windows to take in the surrounding views, such as comedian Ole Olsen's home (above), nicknamed "The House That Laughs Built." Homes covered a range of architectural styles, including adobe, ranch, and mid-century modern. The city contains structures designed by William Pereira, Rudolph Schindler, Albert Frey, Bill Cody, Cliff May, Don Wexler, Stewart Williams, Gordon Kaufmann, and Walter White.

Sandpiper was one of the first condominium projects in the valley and is well known for its design of mid-century units centered around a common area with pool. Architect William Krisel not only planned the units but designed the landscape as well. Krisel used decorative concrete block for both buildings and to create interesting patios. Sandpiper, completed in phases from 1958 to 1966, garnered awards and inspired later projects in Southern California.

Upon marrying Cliff Henderson in 1960, actress Marian Marsh (above left) moved to Palm Desert. She soon noticed the careless littering and dumping occurring in the desert, and she contacted civic leaders about the problem. She founded Desert Beautiful in 1962, with the mission of preserving the beauty of the desert. One of their slogans to improve the appearance of the communities was "Pick-up, Paint-up and Plant." Actor William Holden donated 800 acacia trees for a valley-wide "planting day." Desert Beautiful also reached out to schools to teach children not to litter and instead "Stow It, Don't Throw It," and hosted an essay and poster contest for students as well. From left to right are Bobby Creager, Bill Hanousek, Kevin Thomas, Molly McNeilly, and Ray Hanousek.

Seven

FAMOUS FOLK AND COLORFUL CHARACTERS

In the mid-1960s, the population of Palm Desert was only 5,000. It was a small community where it seemed everybody knew everybody. It was also a community where no matter where you went, you ran into famous folk or local colorful characters. It was not uncommon to run into President Eisenhower at the market, Red Skelton at the bookstore, or Hopalong Cassidy at Keedy's coffee shop. Pictured is Hal Kapp, president of the chamber of commerce, wearing a hat welcoming presidents to Palm Desert. Hal was a local personality: realtor, musician, promoter of the first library, and charter president of the Historical Society of Palm Desert.

Seen departing Mass at Sacred Heart Catholic Church is Pres. John F. Kennedy. Father Alfonse Edwards presided over services during Kennedy's three visits to the church in the 1960s. Here he greets altar boys Kevin McGee (left) and James Olguin (right). Locals recall lining up along the streets near the Palm Springs airport to get a glimpse of the president. Kennedy was in town to relax at Bing Crosby's home in Palm Desert.

Seen with U.S. Rep. Gerald Ford during the summer of 1969 is intern Cathy Swajian, a local student who attended UCLA. Ford later became the 38th president and upon leaving the Oval Office moved with wife, Betty, to Thunderbird Country Club. Both became very active in the Coachella Valley, and the former president could be seen swinging his golf club in the annual Bob Hope Desert Classic. The Fords attended St. Margaret's Episcopal Church in Palm Desert, which played host to the first phase of his funeral service in 2006.

Upon leaving the oval office in 1961, former president Dwight Eisenhower and his wife, Mamie, spent winters at their home in Eldorado Country Club. The general, seen with a young Danny Callahan (above center), had the use of Richfield Oil's DC3 and flew in and out of Palm Desert Air Park. The Eisenhowers became active members of the community and, when in residence, attended services at Palm Desert Community Church. When the congregation outgrew their first location on Portola, Eisenhower was the honorary chairman of the Building Committee and attended the ground-breaking (below) for the new building on Highway 74 in 1967. Interesting to note is the Secret Service officer escorting Eisenhower out of his vehicle. Eisenhower was the first president who, upon leaving office, received lifelong protection from the Secret Service.

In 1957, former president Harry Truman (right) and his wife, Bess, were houseguests of longtime friends Mon (left) and Mabel Walgren. Walgren, from Washington, and Truman, from Missouri, spent more than 20 years together in the U.S. Senate. Walgren later became governor of Washington and upon retirement built a home in Palm Desert. He was an avid golfer and active member at the Shadow Mountain Club.

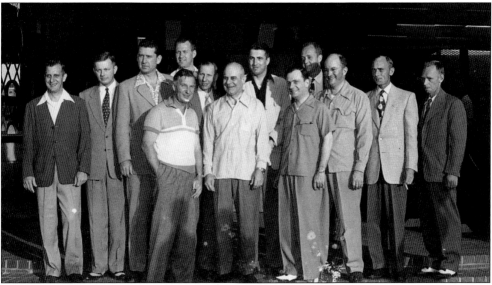

Gen. James Doolittle and his Tokyo Raiders held their 1950 reunion at the Shadow Mountain Club. Doolittle (center) and his squadron were hosted by high school classmate Cliff Henderson, to his right. The Japanese attack on Pearl Harbor in 1941 made U.S. entry into World War II inevitable. In 1942, the Raiders launched a surprise air attack on major Japanese cities, which boosted morale for the Americans.

Edgar Bergen and his family would fly out to the desert in their Piper Apache, landing at Palm Desert Airpark. Bergen, an early rancher in Palm Village, was also one of the investors in the Palm Desert Corporation. As members of Shadow Mountain Club, they attended many of the activities and were well known by all. He is seen here poolside with daughter Candy (Candice), who grew up to become an accomplished actress.

Before the city incorporated in 1973, Palm Desert installed honorary mayors to represent the citizens. Dolores Hope (left), wife of Bob Hope, is being congratulated on becoming the 1969 mayor by former actress Marian Marsh Henderson. Hope acted as honorary mayor for five years.

Actor Tab Hunter (right) and Ronnie Robertson, Olympic ice skater, are seen poolside at the Shadow Mountain Club. Hunter was a popular screen idol in the 1950s and appeared in over 40 movies, including World War II drama *Battle Cry* and *Damn Yankees*. He also reached the top of the charts with his 1957 hit song "Young Love." Early on, Hunter and actor friends came to Palm Desert to work on the homestead cabin of his agent Dick Clayton up in Cahuilla Hills. With no running water at the cabin, they would go to the club to shower and clean up. Downtime was spent relaxing by the pool and basking in the sun. In a recent communication, Hunter stated, "Palm Desert and the Shadow Mountain Club was a place for us to unwind. . . It was a totally different time in a totally different world . . . A world where less was oh so much more."

Cliff Henderson (left) and Monty Montana (right) have exchanged the tools of their trades—a tennis racket for a Stetson. Montana, famous for trick riding and roping, appeared in over 30 Western movies and was a fixture in the Rose Parade. His most famous roping victim was President Eisenhower, who, to the dismay of the Secret Service, agreed to the stunt during the presidential inaugural parade in 1953.

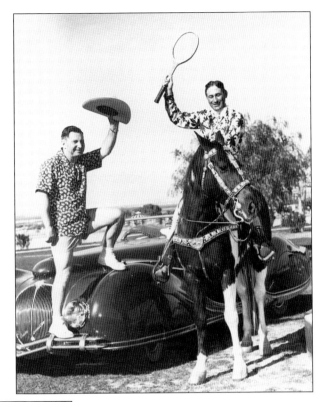

Callahan/Gogerty Collection

Actor John Wayne took time to pose with fans at the Palm Desert Airpark. Wayne used the airpark as a layover point while en route to Mexico to shoot a movie. He spent the night at Desert Air Hotel to get an early start in the morning, as flying at night in Mexico was prohibited. During the 1960s, Wayne filmed five "chili" Westerns in Mexico.

Resident William Boyd donned his Hopalong Cassidy regalia for the dedication of the new frontage road in 1961. Rather than cutting the ceremonial ribbon, Hopalong shot it with his six shooter. To his left is his wife, Grace, fondly known as Tripalong because of her trying to keep up with her long-legged husband. This was only the second, and final, time he donned the outfit while living here, choosing instead to quietly fit into the community.

Upon his retirement from films, William and Grace Boyd built a home in Palm Desert and resided here for over 15 years. Their home was painted his signature colors of black and white, and the metalwork by the front door contained the initials of his famous character Hopalong Cassidy—H. C. The home still maintains the color scheme and is at 73498 Joshua Tree Street.

Hopalong Cassidy's Creed

for American Boys and Girls

1. The highest badge of honor a person can wear is honesty. Be truthful at all times.

2. Your parents are the best friends you have. Listen to them and obey their instructions.

3. If you want to be respected, you must respect others. Show good manners in every way.

4. Only through hard work and study can you succeed. Don't be lazy.

5. Your good deeds always come to light. So don't boast or be a show-off.

6. If you waste time or money today, you will regret it tomorrow. Practice thrift in all ways.

7. Many animals are good and loyal companions. Be friendly and kind to them.

8. A strong, healthy body is a precious gift. Be neat and clean.

9. Our country's laws are made for your protection. Observe them carefully.

10. Children in many foreign lands are less fortunate than you. Be glad and proud you are an American.

Hopalong Cassidy's "Creed for American Boys and Girls" is remembered well by the fans of his show and members of his Troopers Club. With two million members, the club rivaled the Boy Scouts in numbers. Hoppy never swore, drank, smoked, or kissed girls, and he encouraged his young viewers to follow his code of conduct. As the Hopalong Cassidy character was indelibly associated with William Boyd, many of Boyd's obituaries actually referred to him as Hopalong Cassidy.

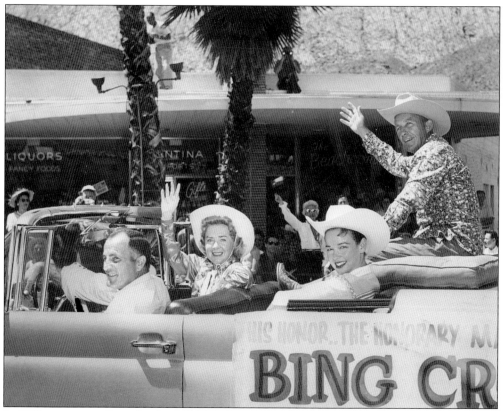

In 1958, entertainer Bing Crosby took his job as the first honorary mayor of Palm Desert seriously and was regularly out promoting the new community. Seen here riding in the Palm Springs Desert Circus Parade is Bing (right) with his recent bride, Kathryn Grant. Waving from the front seat is actress Alice Faye, while Pete Petitto takes the wheel. Besides appearing in numerous movies, Crosby recorded the bestselling song of all time, "White Christmas."

Bing Crosby's Palm Desert home was located at the top of the cove, in what is now Ironwood Country Club. While he later owned other homes in the valley, it was here that President Kennedy stayed during two visits to the desert. The picture looks south with a snowcapped Santa Rosa Mountain in the rear.

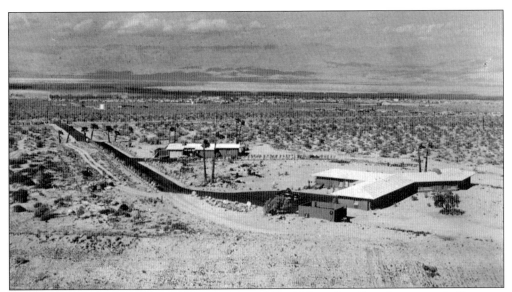

The Crosby home was located at the southern edge of Silver Spur Ranch, surrounded by open desert. Songwriter Jimmy Van Heusen and writer/producer Bill Morrow built homes adjacent to Crosby. Local columnist Gloria Greer recalls looking up the hill to see if there were lights on at Crosby's home, thus knowing if he was in town.

Prior to 1962, there was no local cable television company in Palm Desert and only two channels could be received with rabbit ears. This bothered Bing Crosby so much that in 1962 he and investors started Abel Cable/Desert Cable TV. Bing is seen with the company manager, Phil Franklin (left), and friend Phil Harris (right) adjusting knobs at the cable company. The first year, they offered 5 channels and eventually increased to 20.

Velma Dawson, another early resident, got her start as a puppeteer working with Edgar Bergen and Charlie McCarthy on the vaudeville circuit. Dawson is best known for building the puppet Howdy Doody, which she designed with 48 freckles, one for each state. "It's Howdy Doody Time!" delighted audiences from 1947 to 1960. Other marionettes designed by Dawson can be seen at the Historical Society of Palm Desert. Below, Velma and her husband, Johnny, are seen greeting actors Dennis Weaver, Hugh O'Brien, and Lloyd Bridges. Johnny Dawson was instrumental in the development of Thunderbird, El Dorado, Seven Lakes, and Marrakesh Country Clubs.

Filming of the 1963 hit *It's a Mad, Mad, Mad, Mad World* brought Hollywood to the valley in the heat of the summer. With Smiler Grogan (played by Jimmy Durante) "kicking the bucket" after a crash on winding Highway 74, the search begins for his treasure buried at "The Big W." Barbara Keedy Eastes recalls working at her father's coffee shop that summer and mixing up 20 milkshakes that were then frozen before being delivered to the hungry cast and crew. Unbeknownst to him, this gas station from the movie was constructed on Jimmy Van Heusen's property adjacent to Highway 74. Not realizing it was a temporary set, Van Heusen assumed his business manager had leased the land for a service station. The next time he saw the station, it was in ruins. Van Heusen assumed there had been an accident and was concerned he could be liable for the damage.

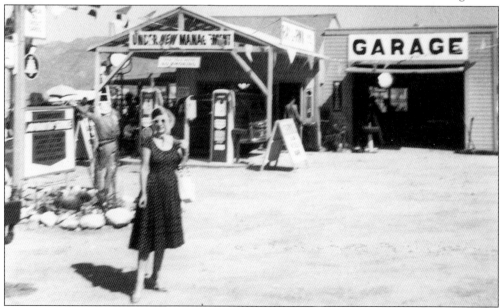

Seen here at the entrance to the club, Dakar was the unofficial mascot of the Shadow Mountain Club. Cliff Henderson's Great Dane was named for the port in West Africa, where Cliff served as military commissioner during World War II. Henderson claimed the mountains around Palm Desert reminded him of the Atlas Mountains in Northern Africa.

Caricature artist Frank Dunn had his 10 minutes of fame in the 1930s for a uniquely shaped shrub root he found in the desert. Nicknamed the Ho Hum Man by *Ripley's Believe It or Not!*, the root resembled a man stretching his arms and legs. This discovery led to a lifelong search for roots that took the shape of animals. A portion of his collection—or "zoo," as he liked to call it—was even displayed in the window of Saks Fifth Avenue in New York in 1934.

Gary Olesen is surrounded by Queen Scheherazade and her court at the Indio Date Festival grounds in 1966. Gary, son of early residents Kay and Dolly Olesen, chauffeured Queen Scheherazade in the annual parade. His father, Kay, was a Riverside County Planning Commissioner for over 20 years and served on the Coachella Valley Recreation and Park District Board for 25 years. A local baseball park—Olesen Field—was named in his honor.

Bob Green served 38 years as a firefighter, starting as a volunteer and retiring as a battalion chief in 2000. Through the years, he and his wife, Carolyn, acquired an extensive collection of vintage firefighting equipment, trucks, tools, and memorabilia. They have kindly loaned the Historical Society of Palm Desert many early firefighting "tools of the trade," which are on display in the old fire station.

Harry Oliver, an Academy Award–nominated art director from films of the 1920s and 1930s, eventually escaped Hollywood for a simpler desert life. He initially settled in Borrego but later built Fort Oliver in Thousand Palms. A humorist, Oliver wrote many stories for *Desert Magazine* and also produced his quarterly *Desert Rat Scrap Book* newspaper, which he claimed was the only paper you could open in the wind. Harry perpetuated the story of Peg Leg Smith's Lost Gold Mine by planting wooden peg legs and gold painted rocks in abandoned mines. Harry also coined the term "Litterbug" and crusaded against folks littering in the desert. Marian Henderson had Walt Disney draw a caricature of Harry (below), which became the symbol of Desert Beautiful.

Andrew Rolan was known to all as simply Andy the Donkey Man. Andy occupied the cove near present-day Painters Path, living in his covered wagon and giving donkey rides to the local children. In the summer, Andy would hitch up his donkeys to his homemade wagon and make his way up Highway 74 to Lake Hemet, where it was cooler. He gained national recognition in 1973 when featured on the CBS show *On the Road with Charles Kuralt*. After 40 years of walking valley streets, Andy was killed crossing Highway 111 on New Year's Eve 1973. A water fountain at Washington School was dedicated to his memory. As a special treat, fire chief Jim McClellan took sons Dave (left) and Mark (right) to ride on Andy's donkeys in 1971.

Betty Crockett (left), seen with resident character Jerry Malone, moved to Palm Desert in 1956 to serve as lifeguard at the Shadow Mountain pool. She loved working with children and soon became the youth activities director, planning events for the Kookie Kids, Kats, and Kittens who ranged in age from 4 to 12. Besides staging swim contests and shows at the club, she also took them hiking in the local canyons. While she had no children of her own, "Miss Betty" considered these children her kids and would have laid down her life for them. She has kept in touch with many of them, and over 50 of her "kids" recently reunited to help Betty celebrate her 70th birthday. Always a good sport, Betty agreed to play the leading role in "The Angel in the Christmas Tree" skit (below).

Eight

TODAY IN PALM DESERT

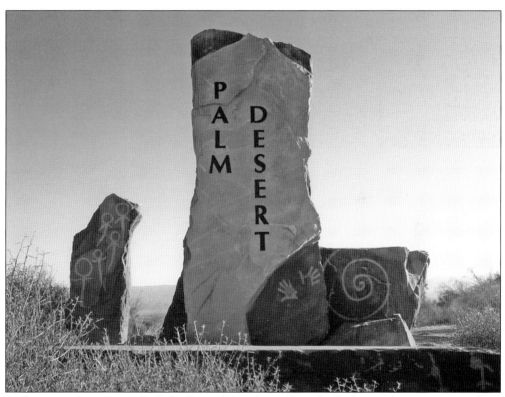

In the span of a century, the Palm Desert area changed markedly from its origins as a ranching area and small community of Palm Village. Today Palm Desert is home to over 40,000 year-round residents, offers a variety of outdoor and recreational activities, and boasts that El Paseo is the "Rodeo Drive of the Desert." The College of the Desert was the first institution of higher education in the Coachella Valley, and University Park on the northern edge of the city is the site of two four-year universities. The city takes pride in its cultural amenities, notably the McCallum Theatre and Art in Public Places programs. The facilities and amenities offered in the city are first-class and a reason it continues to be one of the most desired locales in the valley. The city's foundation was set by the community planning and development efforts of the Henderson family. The spirit of growth and opportunity continues to prevail in the city today.

The Palm Desert Visitor Center (left) was the first LEED (Leadership in Energy and Environmental Design) certified building in the Coachella Valley when it opened in 2005. Designed by Reuel Young, this environmentally friendly building set a new standard in construction by incorporating solar panels, drought tolerant landscaping, and even using sunflower seed husks in cabinet construction. Located at 72567 Highway 111 and open daily from 9:00 a.m. to 5:00 p.m., the Visitor Center is well stocked with information and souvenirs for both visitors and residents alike. Adjacent to the Visitor Center is the newly constructed Henderson Community Building, also LEED certified, designed by Narendra Patel. Home to the Palm Desert Chamber of Commerce, the building is named after the Henderson family.

In 1974, community members formed Friends of the Cultural Center and committed to building a performing arts center. Resident and entertainer Fred Waring performed 13 sold-out concerts to benefit the center, and soon other community leaders lent their support as well. Opened in 1988, the McCallum Theatre hosts a variety of shows and provides educational opportunities for children as well.

As the first city in Riverside County to establish a public art program, Palm Desert has made art very much a part of daily life. Established in 1986, the Art in Public Places program is funded through developer fees, and this permanent collection has grown to over 130 pieces. While pieces are found throughout the city, many works such as this one are located in Civic Center Park. This catcher welcomes players to the baseball fields.

Located in the heart of the city is Civic Center Park, the largest of the 14 public parks. At over 70 acres, the park, with its amphitheater, lagoon, sports fields, playground, and walking paths, serves the recreational needs of all members of the community. Civic Center Park also contains one of the two skate parks in the city. Even dogs, both large and small, have their own special area in which to run and socialize.

While Civic Center Park has a lovely rose garden, it also contains a garden unique to the desert—a date grove. The city date grove stands as a reminder of the early date ranches in Palm Village. The grove is tended and harvested; and although they are not available for purchase, the Deglet Noor dates are used for city promotion.

A diverse trail system allows hikers, both novice and experienced, access to majestic views not available from the valley floor. Trailheads are located at Homme/Adams Park and Cahuilla Hills Park along the hills to the west, at The Living Desert, and at the Santa Rosa and San Jacinto Mountains National Monument Visitor Center at the base of the mountain on Highway 74.

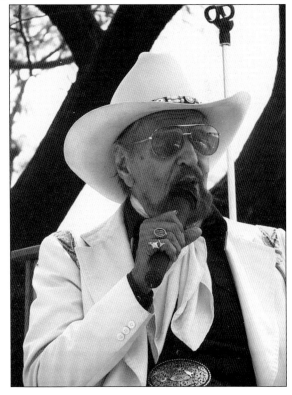

Herb Jeffries, the legendary "Bronze Buckaroo" cowboy, was honored by the city with a hiking trail. The Herb Jeffries Trail was dedicated April 2, 2005, and the former resident entertained the crowd with his tales and songs. The Hopalong Cassidy and Randall Henderson Trails were also named after early residents who had an interest in the outdoors.

It is hard to believe that over 60 years ago, the planners who envisioned the new community of Palm Desert intended El Paseo to be a high-end shopping boulevard. While it remained largely sandy open space for the first 30 years, growth was steady. El Paseo has reached the goal set by the founders, and shoppers now enjoy boutiques, galleries, and outdoor dining on the mile-long street. The annual golf cart parade is held on El Paseo.

First established in the 1960s by residents as the Christmas in July Parade, the renamed Golf Cart Parade continues to this day. Through the years, the parade has grown from featuring simple, decorated carts to elaborate floats built over golf carts. Thousands of residents and visitors alike line El Paseo in the fall to view this unique parade. The only gas-powered vehicle in the procession is the HSPD fire truck, which traditionally concludes the parade.

Desert Willow Golf Resort, developed and owned by the city, offers two 18-hole championship golf courses to challenge players of all levels. Desert Willow was featured on the cover of *Smithsonian* magazine as a testament to the environmentally sensitive design incorporated in the course. Native desert plants are integrated around green fairways, and recycled water is used for irrigation. The municipal course welcomes visitors, and through the Resident Golf Card Program, Palm Desert residents have the opportunity to play at Desert Willow for a reduced rate. The restaurant at Desert Willow offers stunning views of the course and surrounding mountains and is a wonderful place to enjoy breakfast or lunch.

The annual Mini Muster, hosted by the Historical Society of Palm Desert in cooperation with the city fire department, is offered to all third-grade students in the city. Mini Muster, held during Fire Prevention Month, offers students the chance to learn about fire safety and firefighting techniques in a fun, safe environment. Now in its 16th year, Mini Muster is very popular with the local children.

HSPD offers school tours to all the second graders in the city and even provides bus service to transport the children. The second graders learn the history of the city, the importance of water in the desert, and the history of firefighting tools. A visit concludes with a photograph in front of the historic fire engine.

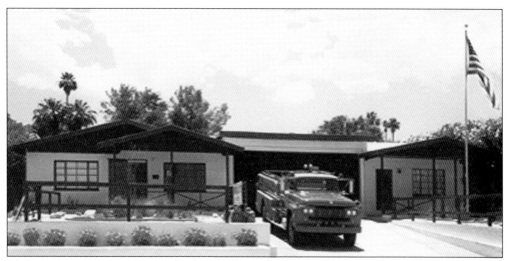

The first fire station in the city, built in 1951, is now home to HSPD. The building contains an exhibit chronicling the city's history and displays of early firefighting equipment. A vintage red fire engine parked near the building's entrance is a featured attraction and an iconic image in the city. Visitors and school tours are welcome.

Former president Eisenhower was an avid golfer and every year received a new model golf cart. His "old" golf cart became highly coveted. This cart, with Eisenhower's initials on the hood, was stored for years in the garage of former chamber of commerce president Don McNeilly. His daughter Molly kindly donated it to HSPD, and visitors are welcome to stop by and see it at 72861 El Paseo. Pictured with the cart are the authors of this book.

ACROSS AMERICA, PEOPLE ARE DISCOVERING
SOMETHING WONDERFUL. THEIR HERITAGE.

Arcadia Publishing is the leading local history publisher in the United States. With more than 4,000 titles in print and hundreds of new titles released every year, Arcadia has extensive specialized experience chronicling the history of communities and celebrating America's hidden stories, bringing to life the people, places, and events from the past. To discover the history of other communities across the nation, please visit:

www.arcadiapublishing.com

Customized search tools allow you to find regional history books about the town where you grew up, the cities where your friends and family live, the town where your parents met, or even that retirement spot you've been dreaming about.